THE BEST OF
DIGITAL WEDDING
PHOTOGRAPHY

BILL HURTER

AMHERST MEDIA, INC. ■ BUFFALO, NY

ABOUT THE AUTHOR

Bill Hurter is the editor of *Rangefinder* magazine. He is the former editor of *Petersen's PhotoGraphic*, and is a graduate of Brooks Institute of Photography, from which he holds a BFA in professional photography and an honorary Masters of Science degree. He has been involved in professional photography for more than twenty-five years. Bill is also the author of *Portrait Photographer's Handbook, Group Portrait Photography Handbook, The Best of Wedding Photography, The Best of Portrait Photography, The Best of Children's Portrait Photography, The Best of Wedding Photojournalism*, and *The Best of Teen and Senior Portrait Photography*, all from Amherst Media.

Copyright © 2004 by Bill Hurter.
All rights reserved.

Published by:
Amherst Media, Inc.
P.O. Box 586
Buffalo, N.Y. 14226
Fax: 716-874-4508
www.AmherstMedia.com

Publisher: Craig Alesse
Senior Editor/Production Manager: Michelle Perkins
Assistant Editor: Barbara A. Lynch-Johnt

ISBN: 1-58428-145-6
Library of Congress Card Catalog Number: 2004101347

Printed in Korea.
10 9 8 7 6 5 4 3 2 1

TABLE OF CONTENTS

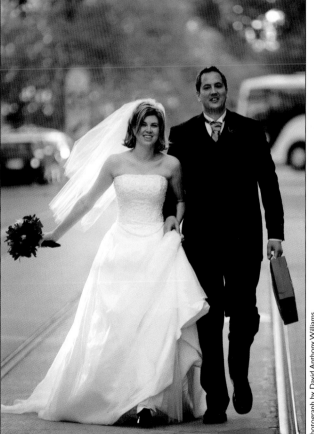

Photograph by David Anthony Williams.

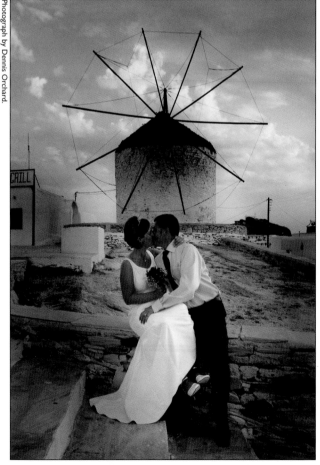

Photograph by Dennis Orchard.

Photograph by Marcus Bell.

INTRODUCTION

*L*iving in these times, it is not at all hard to believe that technology could play a role in redefining a time-honored tradition like wedding photography. However, the influence of digital technology on weddings and wedding photography has been more than merely *significant*, it has been *mind-boggling*. Digital technology has literally reversed fortunes, providing prosperity and unparalleled success for a new generation of all-digital wedding photographers. Thanks to digital, wedding photography is an art-form that is virtually exploding with creativity! Despite economic ebbs and flows, wedding budgets seem to know no bounds and the horizons of wedding photography appear almost limitless.

THE ADVANTAGES OF DIGITAL

Control. Photographers are no longer just recording images and sending them to the lab for color correction, retouching, and printing. Says Kathleen Hawkins of Jeff Hawkins Photography, "We can now perfect our art to the fullest extent of our vision!"

Steven Gross is a highly successful wedding photojournalist who shoots weddings in black & white only. His images reflect frozen moments unobserved by most of the wedding guests.

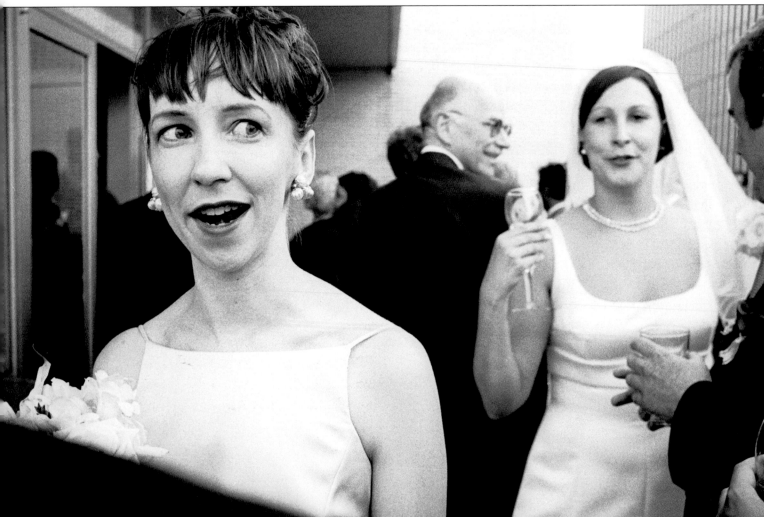

LEFT—Joe Photo photographed a dream wedding, which included six different locations all over the world. This image of the bride was made outside of Paris. This kind of coverage is indicative of the changed face of wedding photography. **RIGHT**—Today's wedding photographer is a keen observer of the day's events. This image by award-winning photographer Regina Fleming is a study in motion and form that isolates the emotion of the wedding day.

The photographers featured in this book are digital artists who spend a great deal of time perfecting each image that goes out to a client. It is probably this aspect of contemporary wedding photography, more than any other, that has accounted for the profound increase in artistic wedding images.

This fine-art approach, in turn, raises the financial bar—allowing digital wedding photographers to charge premium prices for their weddings. Says photographer David Beckstead, "I treat each and every image as an art piece. If you pay this much attention to the details of the final image, brides will pick up on this and often replace the word 'photographer' with the word 'artist.'"

For Charles and Jennifer Maring, digital has opened up a wealth of creative opportunities. Their unique digital albums include an array of beautifully designed pages with graphic elements that shape each layout. Their storytelling style is as sleekly designed as the latest issue of *Modern Bride*. The Marings not only work each image but also design each album. Says Charles, "There is a unique feeling when designing the art. I don't know what an image will look like until I am almost done with it. I also don't know where the vision comes from. I relate this to the art of photography. A higher place maybe."

This talented couple believes so totally in controlling the end product that they also own their own

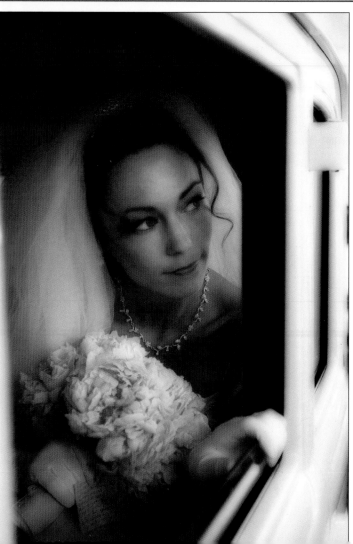

FACING PAGE, TOP—This beautiful panoramic image for an album was made by Charles Maring and toned and softened in Photoshop. The lighting on both the couple and the car is exquisite, and the design of the image places the couple on the left-hand page of the album and the bulk of the car on the right-hand page. The panoramic was designed as a 15x10-inch page. **FACING PAGE, BOTTOM LEFT**—Joe Buissink, a master wedding photographer, likes the look of film. Therefore, his digital arsenal includes both film and digital Nikon cameras. He is the master of the subtle moment—as shown here, where he captured this young wedding attendant in the midst of a self-approving moment. **FACING PAGE, BOTTOM RIGHT**—Digital has allowed photographers to reach new heights in creativity, primarily because they control the processing and post-processing of the image. In this image by Jeff and Kathleen Hawkins, various effects (controlled blurring, vignetting, dodging, and burning) were performed in Adobe Photoshop, making the final image a unique work of art. **RIGHT**—David Beckstead works in Photoshop on every single image that leaves his studio, insisting that this kind of attention to detail is the only way to preserve the "art" of the wedding image. The original image was made with a Nikon D1X and zoom lens at the 35mm setting at an exposure of $^1/_{30}$ second at f/2.8. The motion blur was added and enhanced in Photoshop.

digital lab, named Rlab. "We have been totally digital for six years now, and the challenge and precision of the change has actually made us better photographers than we were with film," says Charles. He believes the outside of the album is every bit as important to his upscale clients as each page therein, and has been known to use covers ranging from black leather, to metal, to red iguana skin. He has even found a local bookbinder with his own working bindery for finishing their digital albums.

Digital Imaging Software. Regardless of whether a photographer shoots weddings digitally or with film (indeed, many have not yet made the investment in digital, opting to scan their film images instead), the impact of Adobe Photoshop has permanently changed the style and scope of wedding imagery. In the comfort of his home or studio, the photographer can now routinely accomplish special effects that in years past could only be achieved by an expert darkroom technician. Photoshop has made wedding photography the most creative venue in all of photography—and brides love it. Digital albums, assembled with desktop publishing software, have become the preferred album type of brides, and the style and uniqueness that these albums bring to the wedding experience make every bride and groom a celebrity.

Unlimited Shooting. Ask any wedding photographer shooting film if he or she mentally inventories the number of exposed and unexposed rolls during the wedding day and they'll all tell you that they do it. They also mentally calculate the fees of buying, processing, and proofing that film. Not so with digital, where there are no film and processing costs. Noted San Francisco–area wedding photojournalist, Bambi Cantrell, routinely shoots over 1000 exposures at her weddings. Having switched to digital helps to make this easier, since she can download memory

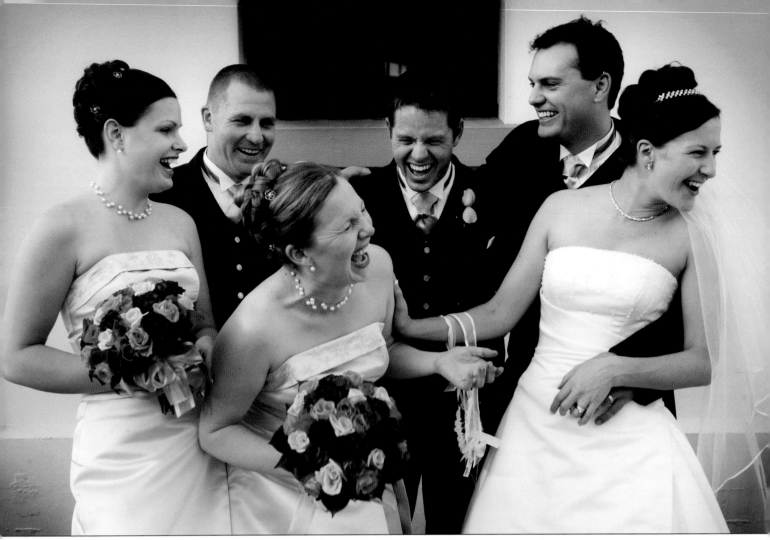

Great wedding photographers must not only possess artistic abilities, but also great timing. Here, Marcus Bell isolated a priceless moment with the wedding party. Note, too, the subtle corner vignetting that keeps the viewer's eye trained on the delighted group.

cards to a laptop and then reuse them or make sure to bring extra memory cards for this purpose.

Instant Image Review. Digital capture also provides the ability to instantly review images on the camera's LCD monitor, meaning that if you missed the shot for whatever reason, you can delete that file and redo it right then and there. It may take a few test shots, sometimes, to adjust the camera, but that's infinitely better than shooting several rolls and then waiting until after the wedding to see what happened. While learning to read your images on the LCD monitor is sometimes tricky, particularly at first, the more you shoot and transfer files to the computer where they are re-evaluated, the more proficient you'll become at determining optimum exposure and focusing accuracy from off the LCD.

That kind of insurance is priceless. Says Kathleen Hawkins, "Think about it—you're photographing the first dance, capturing the couple from all angles

and possibly using your assistant to backlight them. You see that the background light is not bright enough or that your on-camera flash misfired. With digital, instead of waiting a week or two to see that you blew it, you can adjust the lighting and move on."

Additionally, shooting digitally means that the originals are immediately ready to be brought into Photoshop for retouching or special effects and subsequent proofing and printing. The instantaneous nature of digital even allows photographers to put together a digital slide show of the wedding ceremony to be shown at the reception. Jeff and Kathleen Hawkins routinely provide this amazing service at weddings they photograph.

Being able to review your images instantly and shoot as much as you want also has creative advantages. Noted wedding photographer Kevin Kubota hasn't shot a wedding on film since he purchased his

Nikon D1X digital camera, saying that the quality is at least as good as 35mm film and that the creative freedom digital affords him is mind-boggling. He can take more chances and see the results instantly, immediately knowing whether or not he got the shot. And the digital tools he has come to master in Photoshop make him a better, more creative photographer.

Flexibility. Today's digital shooters are not hampered by having to change rolls of film or being caught with the wrong speed film in the camera. You can change film speeds from ISO 100 to ISO 800 or 1600 from frame to frame. You can alter the white balance at any time to correct the color balance of the lighting, and you can even change from color to black & white shooting modes with certain cameras—all at

the touch of a button. This speed and flexibility supports the "on the fly" shooting style of wedding photojournalism, a style of unposed imagery that evolved at roughly the same time as digital technology became prominent in the field.

Archival Permanence. Another benefit of digital is its archival permanence. Traditional photographic film and prints achieve archival status by having a reduced chemical reactivity of their basic components. In other words, the dyes, pigments, and sub-

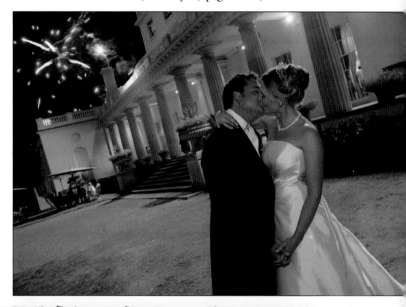

RIGHT—Dennis Orchard created this memorable wedding image in very low light using a strobe to fill the shadows and color-correct the lighting on the couple created by the outdoor tungsten lighting. The fireworks were added later in Photoshop. This kind of image-making pizazz is what modern brides expect in their wedding pictures. **BELOW**—Kevin Kubota hasn't shot a wedding on film since he purchased his Nikon D1X digital camera. The title of this image is *Run with Me*. Photograph by Kevin Kubota.

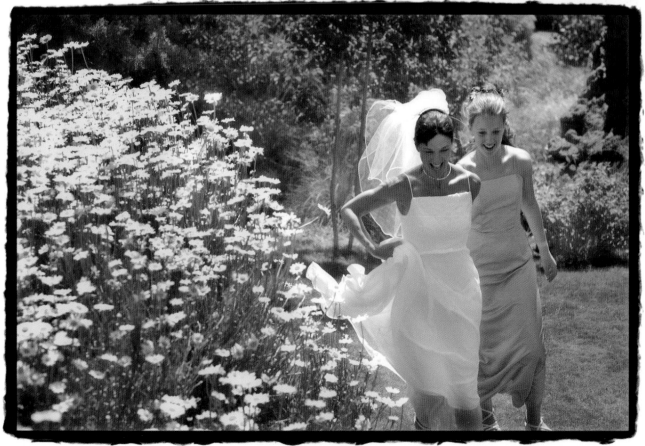

strates used in their creation remain stable over time (provided that storage or display conditions are optimal). A digital image, on the other hand, is stable over time and there is no degradation in copying. Every copy is a perfect copy. Multiple copies stored on stable media assure survivability and endurance over time.

The Internet. The Internet also plays a huge role in the life of the digital wedding photographer. On-line proofing and sales have become a big part of every wedding package. Couples can check out their images while on their honeymoon by going to the photographer's web site with the prescribed password—all from the comfort of their hotel room or a digital café. The use of FTP (file transfer protocol) sites for transferring files to the lab has now become routine. Album design software, which often relies on the use of small manageable files, called proxies, now

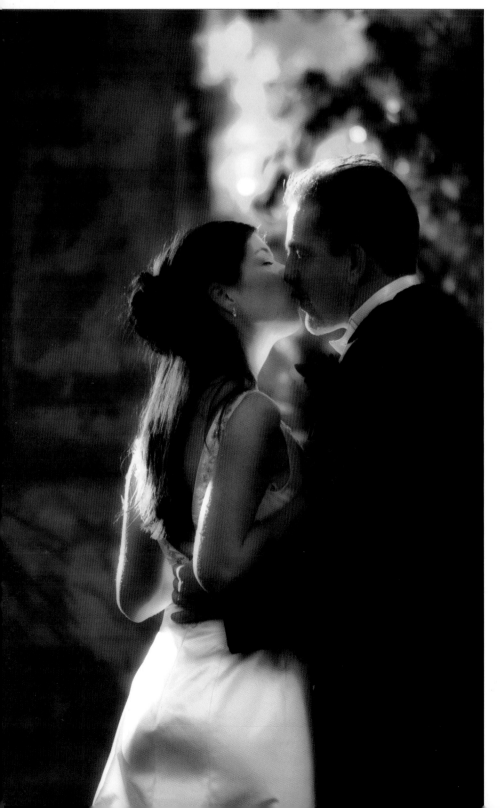

allows the photographer to quickly and fluidly design the album and upload it for proofing or printing.

Hardware. New digital camera systems are appearing almost daily, as are peripheral products that support digital imaging. Almost without exception, the manufacturers of photographic equipment are devoting their entire research and development budgets to new digital products. New cameras with higher resolution, improved imaging chips with added functionality, and better software for handling digital files are being introduced with ever-greater frequency.

It is easy to get caught up in the hardware of digital photography. It is expensive, exotic, and amazingly productive. Yervant Zanazanian, an award-winning Australian photographer puts hardware in perspective. "A lot of photographers still think it's my tools (digital capture and Photoshop) that make my images what they are. They forget the fact that these are only new tools; image-making is in the eye, in the mind, and in the heart of a good photographer. During all my talks and presentations, I

Filled with golden light and emotion, this back-lit image was shot late in the day and shows the photographer's understanding of the emotion of the event. Soft focus enhances the romance in this image by David Beckstead.

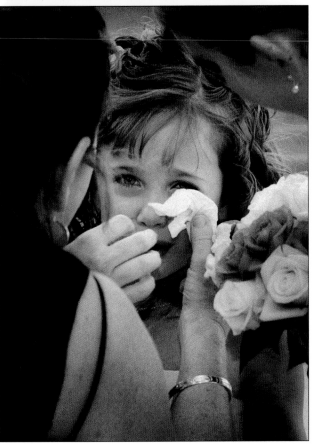

ABOVE—One of the best things about digital is that with some cameras you can capture images in black & white or change from black & white to color on the fly, so you can quickly capture one of each. Photograph by David Anthony Williams. **LEFT**—Emotions are worn on the sleeves of everyone involved in the wedding. The reward of fine images goes to the observant photographer on the lookout for such poignant moments. Photograph by award winner Marcus Bell. The image was captured with a Canon 1Ds and Canon zoom lens (at 52mm) at ISO 400 with on-camera flash used to add just a twinkle to the little girl's eye.

always remind the audience that you have to be a good photographer first and that you can't rely on some modern tool or technology to fix a bad image." It's good advice.

A CHANGED WORLD

It is no doubt a changed world where wedding photographers are concerned. The many aspects of digital imaging will continue to impact wedding photography in seen and unseen ways for decades to come.

Charles Maring welcomes the technology, saying, "The main thing that will distinguish photographers in the future will be their print design and album design concepts. Just as photojournalism has become a mainstream concept in fine wedding photography, design is the future."

ACKNOWLEDGMENTS

As you will see from the photographs throughout this book, the range of creativity and uniqueness displayed by today's top digital wedding photographers is incomparable. I wish to thank the many photographers who have contributed to this book—not only

for their images, but also for their expertise. As anyone who has investigated the technical aspects of digital beyond a surface level has no doubt discovered, there are contradictions galore and volumes of misin-

BELOW—Jeff and Kathleen Hawkins include striking images like this as an everyday part of their wedding coverage. **RIGHT**—Contemporary wedding photography has produced world-famous artists—such as Yervant Zanazanian (known simply as Yervant)—who makes unforgettable wedding images with a design flare second to none.

formation surrounding everything digital. It is my hope that throughout this book you will find many of those mysteries unraveled. I also wish to thank the many photographers who shared trade secrets with me for the purposes of illuminating others. Some of their tips, which appear throughout the book, are as ingenious as they are invaluable.

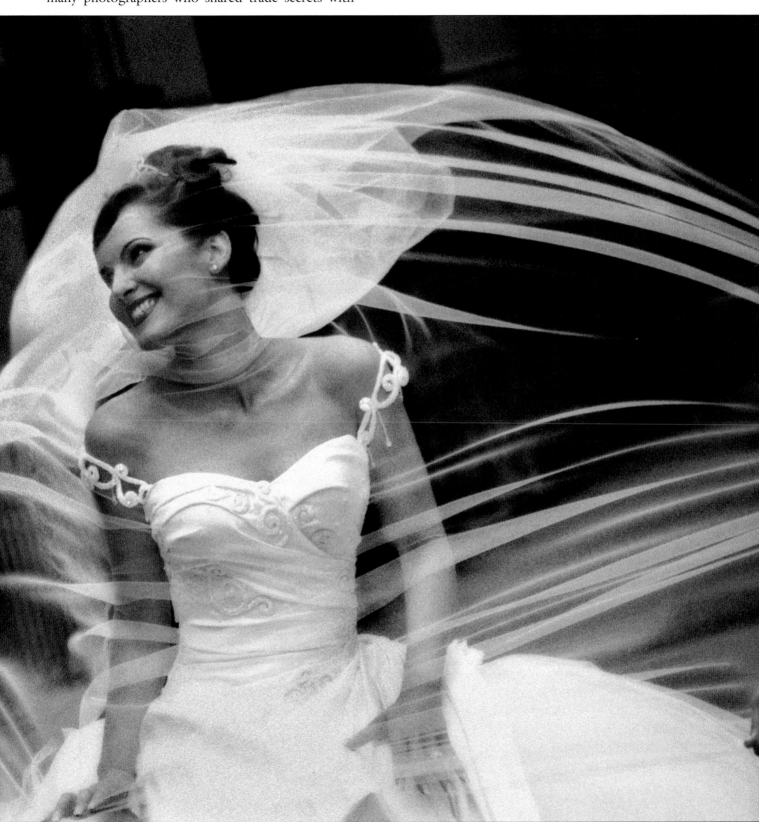

THE PHOTOGRAPHERS

Michael J. Ayers (*MPA, PPA-Certified, M.Photog.,Cr., CPP, PFA, APPO, ALPE, Hon. ALPE*)—The 2001– 2002 International Photographer of the Year (WPPI) and the 2001 United Nations' Leadership Award recipient, Michael J. Ayers is considered one of the best wedding album designers in the world. As the pioneer of exotic wedding album layouts such as pop-up, fold-out, and stand-up pages, he has developed an engineering discipline called album architecture—now the basis for a popular book and video! Michael was also one of the first six AN-NE Award winners (PPA) and was named WPPI's 1997 International Portrait Photographer of the Year.

Stuart Bebb—Stuart Bebb is a Craftsman of the Guild of Photographers (UK) and has been awarded Wedding Photographer of the Year in both 2000 and 2002, with exciting and innovative wedding albums. In 2001, Stuart won *Cosmopolitan Bride's* Wedding Photographer of the Year, in conjunction with the Master Photographers Association. He was also a finalist in the Fuji Wedding Photographer of the Year competition. Stuart has been capturing stunning wedding images for over 20 years. His distinct, stylish, and contemporary photography reflects toady's lifestyle with fun, spontaneous, and classic storybook images that capture the emotion of the wedding day. Stuart works very much as a team with his wife Jan, who creates and designs all the albums.

Becker—Becker, who goes by only his last name, is a gregarious, likeable wedding photojournalist who operates a hugely successful studio in Mission Viejo, California. He has been a featured speaker at WPPI and has also competed and done well in international print competition.

David Beckstead—David Beckstead has lived in a small town in Arizona for 22 years. With help from the Internet, forums, digital cameras, seminars, WPPI, Pictage, and his artistic background, his passion has grown into a national and international wedding photography business. He refers to his style of wedding photography as Artistic Photojournalism.

Vladimir Bekker—Vladimir Bekker, the owner of Concord Photography in Toronto, Canada, specializes in weddings and environmental portraits. An immigrant from the Ukraine, Vladimir took up photography when he was a boy. He is a graduate of Lvov Polytechnical University with a master's degree in architecture, which explains why many of his wedding images include architectural details. His studio photographs over 100 weddings a year. He has won numerous international awards for his prints and albums.

Marcus Bell—There's something compelling about Marcus Bell's photography. His creative vision, fluid natural style, and sensitivity have made him one of Australia's most revered photographers. It's this talent, combined with his natural ability to make people feel at ease in front of the lens, that attracts so many of his clients. His work has been published in numerous magazines in Australia and overseas including *Black White, Capture, Portfolio, Bride,* and countless other bridal magazines.

Joe Buissink—Joe Buissink is an internationally recognized wedding photographer from Beverly Hills, California. Almost every potential bride who picks up a bridal magazine will have seen Joe Buissink's photography. He has done many celebrity weddings, including Jennifer Lopez's 2002 wedding, and is a Grand Award winner in WPPI print competition.

Mike Colón—Mike Colón is a celebrated wedding photojournalist from the San Diego area. Colón's work reveals his love for people and his passion for celebrating life. His natural and fun approach frees his subjects to be themselves, revealing their true personalities and emotions. His images combine inner beauty, joy, life, and love frozen in time. He has spoken before national audiences on the art of wedding photography.

Jerry D—Jerry D owns and operates Enchanted Memories, a successful portrait and wedding studio in Upland, California. Jerry has had several careers in his lifetime, from licensed cosmetologist to black-belt martial arts instructor. He has been highly decorated by WPPI, and has achieved many national awards since joining the organization.

Scott Eklund—Scott Eklund makes his living as a photojournalist for the *Seattle Post-Intelligencer.* His work has appeared in numerous national publications. He specializes in sports, spot news, and feature stories, but recently got interested in photographing weddings, deciding that his skill set was "portable." He has now won numerous awards for his wedding photography, which relies on a newspaperman's sense of timing and storytelling.

Ira and Sandy Ellis—This team of photographers owns and operates Ellis Portrait Design in Moorpark, California. In addition to shooting twenty or so weddings a year, the Ellis team produces children's fantasy portraits—a type of high-end image created around an imaginative concept. Both Ira and Sandy have been honored in national print competitions at PPA and WPPI, and have had their work featured in national ad campaigns.

Deborah Lynn Ferro—A professional photographer since 1996, Deborah calls upon her background as a watercolor artist. She has studied with master photographers all over the world, including Michael Taylor, Helen Yancy, Bobbi Lane, Monte Zucker, and Tim Kelly. In addition to being a fine photographer, she is also an accomplished digital artist. She is the coauthor of *Wedding Photography with Adobe® Photoshop®*, published by Amherst Media.

Rick Ferro (*PPA Cert., M.Photog*)—Rick Ferro has served as senior wedding photographer at Walt Disney World. In his twenty years of photography experience, he has photographed over 10,000 weddings. He has received numerous awards, including having prints accepted into PPA's Permanent Loan Collection. He is the author of *Wedding Photography: Creative Techniques for Lighting and Posing* and coauthor of *Wedding Photography with Adobe® Photoshop®*, both published by Amherst Media.

Regina Fleming—A native New Yorker, Regina Fleming has worked as an airline attendant, a Wilhelmina model, and a Ford Modeling Agency model. She has also appeared in movies and soaps, including *One Life To Live*, *All My Children*, and *As the World Turns*. Considering acting her "hobby," Regina took photography seriously and gained a photography degree from FIT in New York. (She hung out her shingle the same day she graduated from FIT!) A little over a year later, she is already winning awards and turning down wedding bookings.

Tony Florez—For the past 25 years Tony Florez has been perfecting a unique style of wedding photography he calls "Neo Art Photography." It is a form of fine-art wedding photojournalism that has brought him great success. He owns and operates a successful studio in Laguna Niguel, California. He is also an award winner in print competition with WPPI.

Jerry Ghionis—Jerry Ghionis of XSiGHT Photography and Video started his professional career in 1994 and has quickly established himself as one of Australia's leading photographers. His versatility extends to the wedding, portrait, fashion, and corporate fields. Jerry's efforts have been widely recognized in the industry. In 1999 he was honored with the 1999 AIPP (Australian Institute of Professional Photography) award for best new talent in Victoria, and in 2002 Jerry won the AIPP Victorian Wedding Album of the Year. In 2003 he won the Grand Award in the Album competition at WPPI.

Steven Gross—Steven Gross, owner of Real Life Weddings and Steven E. Gross & Associates Photography in Chicago, Illinois, has established a strong reputation for quality imagery during more than 20 years in business. His passionate approach to black & white wedding photography has been featured on ABC's *Good Morning America*, FOX TV, NBC, a PBS documentary, and in *Esquire* magazine. Steven's photographs also illustrated the intro for NBC's sitcom, *Three Sisters*. Steven has also published two books: *Zhou Brothers* (Oxford University Press, 1995), *In the Studio* (Oxford University Press, 1995) and *Black and White: Defining Moments of Weddings and Marriage* (Mohawk Paper, 2002).

Ann Hamilton—Ann Hamilton began her professional career as a journalist writing lifestyle stories for an East Coast newspaper. Now, as a photographer documenting weddings, Ann combines her love of photography with a journalistic sense and artistic flair. Her images capture the true story of a wedding—from the moment a bride slips into her dress, to the couple's first kiss and last dance, and all the joy in between. Ann's work has been featured in *Wedding Bells* and *The Knot* magazines. She also won two honorable mentions at the WPPI International print competition. She and her husband Austin (along with their pug Bogie) reside in San Francisco, CA.

Jeff and Kathleen Hawkins—Jeff and Kathleen Hawkins operate a fully digital, high-end wedding and portrait photography studio in Orlando, Florida. Together they have authored *Professional Marketing & Selling Techniques for Wedding Photographers*, *The Bride's Guide to Wedding Photography*, and *Professional Techniques for Digital Wedding Photography*, all published by Amherst Media. Jeff Hawkins has been a professional photographer for over twenty years. Kathleen Hawkins holds a masters degree in business administration and is a former president of the Wedding Professionals of Central Florida (WPCF), and past affiliate vice president for the National Association of Catering Executives (NACE). They can be reached via their web site: www.jeffhawkins.com.

Elizabeth Homan—Elizabeth Homan owns and operates Artistic Images, a venture in which she is assisted by her husband Trey and her parents Penny and Sterling. They opened their country-styled studio in 1996. Elizabeth holds a BA from Texas Christian University and was decorated as the youngest Master Photographer in Texas in 1998 and the holder of many awards, including 10 Fujifilm Masterpiece Awards, Best Wedding Album in the Southwest Region for six years, and two perfect scores of 100.

Claude Jodoin—Claude Jodoin is an award-winning photographer from Detroit, Michigan. He has been involved in digital imaging since 1986 and has not used film since 1999. He is an event specialist who also shoots numerous weddings and portrait sessions throughout the year. You can e-mail him at claudej1@aol.com.

Kevin Kubota—Kevin Kubota formed Kubota Photo-Design in 1990 as a solution to stifled personal creativity. The studio shoots a mixture of wedding, portrait, and commercial photography. Kubota Photo-Design was one of the first studios to switch to pure digital wedding photography in the late 1990s, and Kevin soon began lecturing and training other photographers on how to make a successful transition from film to digital.

Robert L. Kunesh *(PPA Cert., M.Photog., CPP, AOPM)*— Robert Kunesh has been a professional photographer since 1967. From 1961 until his retirement in 1991, he taught art and graphic arts in various Ohio schools. In 1967, he began photographing weddings for a studio in Cleveland. He has now photographed over 1000 weddings. Since 1986 he has been a co-owner of Studio K Photography and SKP Photo Lab in Willoughby, Ohio. Bob has received numerous awards including a Kodak Gallery award, three PPA Loan Images, and most recently, WPPI's Accolades of Photographic Mastery and Outstanding Achievement, as well as PPA Certification and Master of Photography degrees.

Frances Litman—Frances Litman is an internationally known, award-winning photographer from Victoria, British Columbia. She has been featured by Kodak Canada in national publications, and has had her images published in numerous books, on magazine covers, and in FujiFilm advertising campaigns. She was awarded Craftsman and Masters degrees from the Professional Photographers Association of Canada. She has also been awarded the prestigious Kodak Gallery Award and was named the Photographer of the Year by the Professional Photographers Association of British Columbia.

Charles and Jennifer Maring—Charles and Jennifer Maring own and operate Maring Photography Inc. in Wallingford, Connecticut. Charles is a second-generation photographer, his parents having operated a successful studio in New England for many years. His parents now operate Rlab (resolutionlab.com), a digital lab which does all of the work for Maring Photography, as well as for other discriminating photographers needing high-end digital work. Charles Maring is the winner of the WPPI 2001 Album of the Year Award.

Mercury Megaloudis—Mercury Megaloudis is an award-winning Australian photographer and owner of Megagraphics Photography in Strathmore, Victoria. The AIPP awarded him the Master of Photography degree in 1999. He has won awards all over Australia and has recently begun entering and winning print competition in the United States.

Dennis Orchard—Dennis Orchard is an award-winning photographer from Great Britain. He has been a speaker and an award winner at WPPI conventions and print competitions. He is a member of the British Guild of portrait and wedding photographers.

Joe Photo—Joe Paulcivic III is a second-generation photographer who goes by the name of Joe Photo, his license plate in high school. He is an award-winning wedding photojournalist from San Juan Capistrano, California. Joe has won numerous first-place awards in WPPI's print competition, and his distinctive style of wedding photography reflects the trends seen in today's fashion and bridal magazines. The images are spontaneous and natural rather than precisely posed.

Stephen Pugh—Stephen Pugh is an award-winning wedding photographer from Great Britain. He is a competing member of both WPPI and the British Guild and has won numerous awards in international print competitions.

Fran Reisner—Fran Reisner is a national award-winning photographer from Frisco, Texas. She is a Brooks Institute graduate and has been Dallas Photographer of the Year twice. She is a past president of Dallas Professional Photographers Association. She runs a highly successful low-volume portrait/wedding business from the studio she designed and built on her residential property in Texas. She has won numerous state, regional, and national awards for her photography.

Patrick Rice *(M.Photog.Cr., CPP, AHPA)*—Patrick Rice is an award-winning portrait and wedding photographer with over 20 years in the profession. A popular author, lecturer, and judge, he presents programs to photographers across the United States and Canada. He has won numerous awards in his distinguished professional career, including the International Photographic Council's International Wedding Photographer of the Year Award, presented at the United Nations. He is the author of *The Professional Photographer's Guide to Success in Print Competition, Professional Digital Imaging for Wedding and Portrait Photographers,* and *Digital Infrared Photography,* as well as the coauthor of *Infrared Wedding Photography* (all from Amherst Media).

Martin Schembri *(M.Photog. AIPP)*—Martin Schembri has been winning national awards in his native Australia for 20 years. He has achieved a Double Master of Photography with the Australian Institute of Professional Photography. He is an internationally recognized portrait, wedding, and commercial photographer and has conducted seminars on his unique style of creative photography all over the world.

Michael Schuhmann—Michael Schuhmann of Tampa Bay, Florida is a highly acclaimed wedding photojournalist who believes in creating wedding images with the style and flair of the fashion and bridal magazines. He says of his photography, "I document a wedding as a journalist and an artist, reporting what takes place, capturing the essence of the moment." He has recently been the subject of profiles in *Rangefinder* magazine and *Studio Photography and Design* magazine.

Kenneth Sklute—Beginning his wedding photography career at sixteen in Long Island, NY, Kenneth quickly advanced to shooting an average of 150 weddings per year. He purchased his first studio in 1984, and soon after received his masters degree from PPA. In 1996, he moved to Arizona, where he enjoys a thriving business. Kenneth is much decorated, having been named Long Island Wedding Photographer of the Year 14 times, PPA Photographer of the Year, and APPA Wedding Photographer of the year. In addition, he has earned numerous Fuji Masterpiece Awards and Kodak Galllery Awards.

Jeff Smith—Jeff Smith is an award-winning senior photographer from Fresno, California. He owns and operates two studios in Central California. He is well recognized as a speaker on lighting and senior photography and is the author of *Corrective Lighting and Posing Techniques for Portrait Photographers, Outdoor and Location Portrait Photography, Professional Digital Portrait Photography,* and *Success in Portrait Photography,* all from Amherst Media. He can be reached via his website, www.jeffsmithphoto.com.

Deanna Urs—Deanna Urs lives in Parker, Colorado with her husband and children. She has turned her love and passion for the camera into a portrait business that has created a following of clientele nationally as well as internationally. Deanna uses "natural light" and chooses to have subtle expressions from her clients as she feels these are more soulful portraits that will be viewed as art and as an heirloom. She works in her client's environment to add a personal touch her portraits. Visit Deanna's website at www.deannaursphotography.com.

David Anthony Williams (*M.Photog. FRPS*)—David Anthony Williams owns and operates a wedding studio in Ashburton, Victoria, Australia. In 1992 he achieved the rare distinction of Associateship and Fellowship of the Royal Photographic Society of Great Britain (FRPS) on the same day. Through the annual Australian Professional Photography Awards system, Williams achieved the level of Master of Photography with Gold Bar—the equivalent of a double master. In 2000, he was awarded the Accolade of Outstanding Photographic Achievement from WPPI, and has been a Grand Award winner at their annual conventions in both 1997 and 2000.

James C. Williams—James Williams and his wife Cathy own and operate Williams Photography in Warren, Ohio. James is PPA Certified and also has been Certified through the PPA of Ohio. In 2001 Williams was inducted into the Professional Photographers' Society of Ohio; membership is by invitation only. Currently Williams is working on his Craftsman and Masters Degrees.

Yervant Zanazanian (*M. Photog. AIPP, F.AIPP*)—Yervant was born in Ethiopia (East Africa), of Armenian origin, then lived and studied in Italy prior to settling in Australia 25 years ago. He continued his studies at the Photography Studies College in Melbourne. Yervant's passion for photography and the darkroom began at a very young age, after school and during school holidays working in his father's photography business. His father was photographer to the Emperor Haile Selassie of Ethiopia. Yervant owns one of the most prestigious photography studios in Australia and services clients both nationally and internationally. His awards are too numerous to mention, but he has been Australia's Wedding Photographer of the Year three of the past four years.

1. THE KEYS TO SUCCESS

No other photographic field is more demanding than wedding photography. After all, the couple and their families have made a considerable financial investment in a once-in-a-lifetime event. Should anything go wrong photographically, the event cannot be re-shot. This pressure is why many talented photographers pursue other disciplines of professional photography.

Success requires mastery over a variety of different types of coverage, the ability to perform under pressure, and the technical know-how to work within a very limited time frame. The couple who hired you is not looking for general competence; they are looking for unparalleled excellence. It is the day of dreams, and as such, the expectations of clients have changed drastically in recent years. Couples don't just want a photographic record of the day's events, they want inspired, imaginative images—and an unforgettable presentation. To all but the jaded, the wedding day is the biggest day in peoples' lives, and the images should capture all of the romance and joy and festivity with style.

THE MIND SET

Idealization. One of the traits that separates average wedding photographers from great ones is the ability to idealize. Using all of the tools of composition and design, as well as the entire photographic arsenal of technical skills, and the full gamut of postproduction effects, the exceptional photographer produces extraordinary images in which all the people look their best. Doing this requires an instant recognition

of potential problems as well as the skills to make the needed adjustments.

It is especially important that the bride be made to look as beautiful as possible. Most women will spend more time and money on their appearance for their

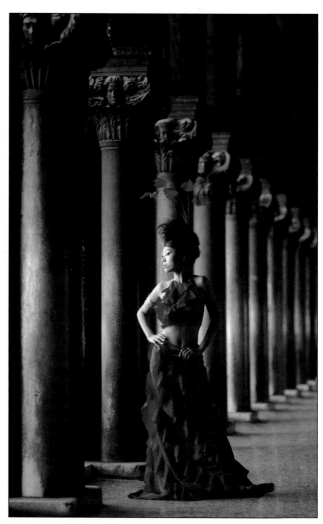

With the eye and skill of a fashion photographer, Joe Photo captured this gorgeous bride in a classic red Chinese gown in the splendid environment of the Chateau de Mirambeau in Mirambeau, France, where the main wedding ceremony occurred. Joe made the image with a Nikon D1X. 85mm f/1.4 AF-Nikkor lens. In the directional shade, he exposed the image at $^1/_{250}$ second at f/1.4.

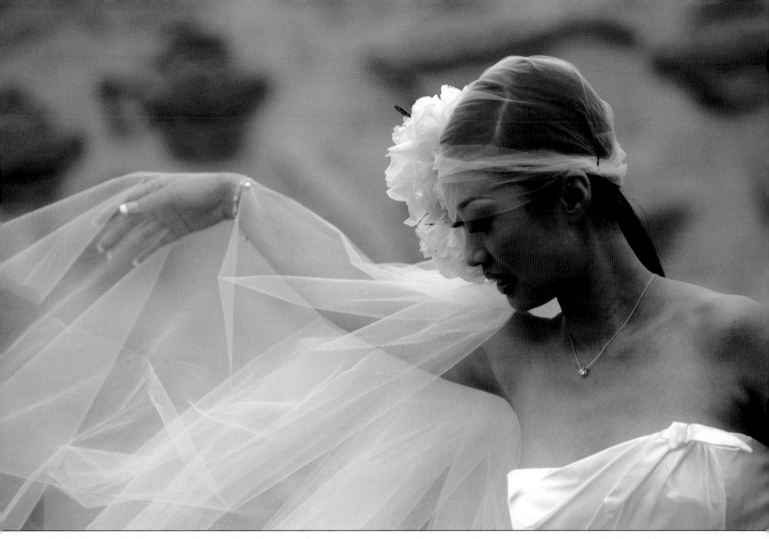

Today's brides don't want merely general competence, they want sustained excellence. Joe Photo created this lovely and whimsical bridal portrait as part of his dream wedding assignment (see pages 33–36). He made the image with a Nikon D1X and an 80–200mm, f/2.8, AF Nikkor lens at an exposure setting of $^{1}/_{350}$ second at f/2.8.

wedding day than for any other day in their lives. The photographs should chronicle just how beautiful the bride really looked.

The truly talented wedding photographer will also idealize the other events of the day, looking for every opportunity to infuse emotion and love into the wedding pictures. In short, wedding photographers need to be magicians. Through careful composition, posing, and lighting (and a healthy knowledge of Photoshop), many "imperfections" can be rendered unnoticeable, idealizing the subject and the day.

Proactive vs. Reactive. Traditional wedding coverage features dozens of posed pictures pulled from a "shot list." Such shot lists are passed down by generations of other traditional wedding photographers. There may be as many as 75 scripted shots—from cutting the cake, to tossing the garter, to the father of the bride walking his daughter down the aisle. In addition to the scripted moments, traditional photographers fill in the album with "candids," many of which are staged (or at least shot when the subjects are aware of the camera).

The digital wedding photographer's approach is quite different. Instead of being a part of every event, moving people around and staging the action, the photographer tends to be quietly invisible, choosing to fade into the background so the subjects are not aware of the photographer's presence. The photographer does not want to intrude on the scene. Instead, he or she documents it from a distance with the use of longer-than-normal lenses and, usually, without flash. This is what digital capture offers: a completely self-contained means of documenting a wedding unobserved.

Because the photographer is working with longer lenses or zoom lenses and is not directing the partic-

ipants to "move here" or "go over there," he or she is free to move around, working quickly and unobtrusively. The event itself then takes precedence over the directions, and the resulting pictures are more spontaneous and lifelike. Plus, there are many more opportunities for original, completely unstaged images that better tell the story of the event.

The "Hopeless Romantic." Perhaps because of the romantic nature of the event, it helps if the wed-

ding photographer is also a romantic—but it's not a necessity. Photographing a wedding is also about the celebration, which is all about having fun. The wedding photographer gets to be part of the joy of the event, and the pictures will tell the story of the celebration. For many the thrill is in the ritual. For others, the thrill is in the celebration; and for others, it's the romance. Michael Schuhmann, a gifted wedding photographer from Tampa, Florida, truly loves his

Michael Schuhmann created this wonderful yet simple shot of the bride and groom entering the limo. Journalistic in nature, the wide-angle lens creates a panoramic effect, encompassing the cityscape, chauffeur, and groom. Note that the beautiful bride is centered in the frame to avoid distortion.

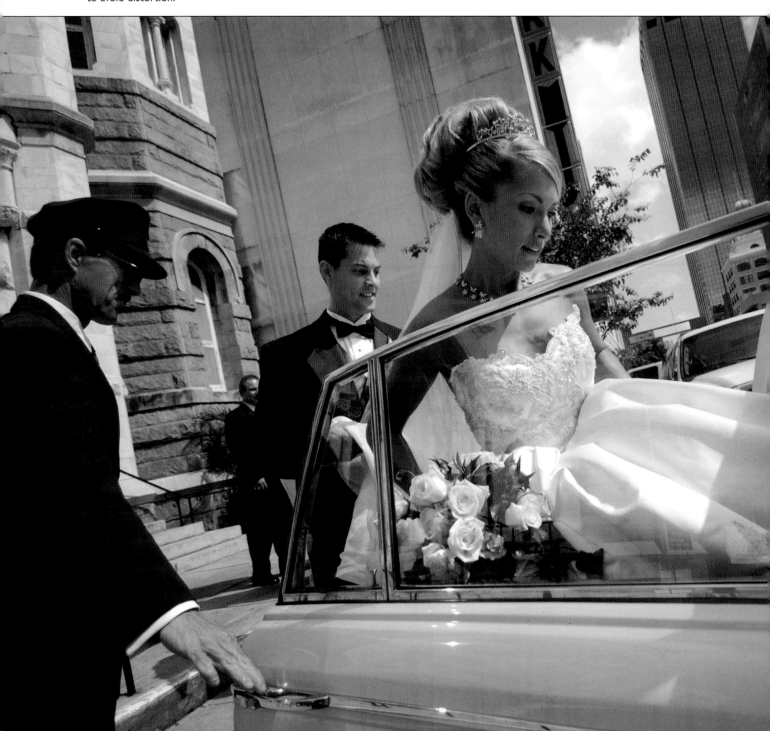

work. He explains, "I love to photograph people who are in love and are comfortable expressing it, or are so in love that they can't contain it—then it's real."

THE SKILLS

Powers of Observation. Like any other form of reportage—be it news, fashion, or sports photography—one of the prerequisites for success is the skill of observation, an intense power to concentrate on the events occurring before you. Through keen observation, a skill that can be enhanced through practice, the photographer begins to develop the knack of predicting what will happen next.

TOP—Group shots are an integral part of any wedding. Even though this is a formal wedding, it is an informally posed group shot in which the closeness and spontaneity of the group take precedence over formal posing guidelines. The image, made by Claude Jodoin, was lit by bounce flash and captured with a Canon IDS and 35mm lens at $^{1}/_{125}$ second at f/5.6. **BOTTOM**—Even though the contemporary digital wedding photographer may not "script" the wedding as in the past, there are still great moments, like the bouquet toss, at each wedding that need to be captured. Claude Jodoin captured this moment with a 35mm wide-angle lens, off-camera flash, and a high ISO in order to more closely match the ambient light level. The result is that the bride, the background, and the priceless expressions are all recorded faithfully.

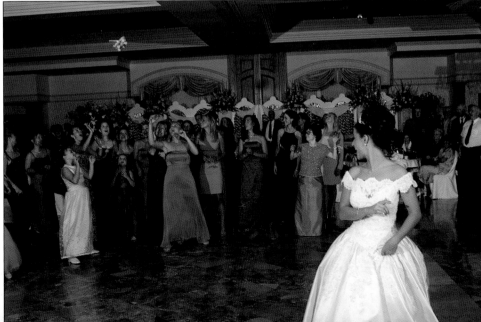

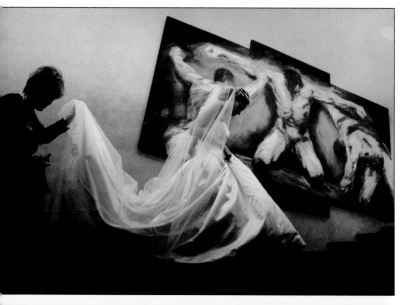

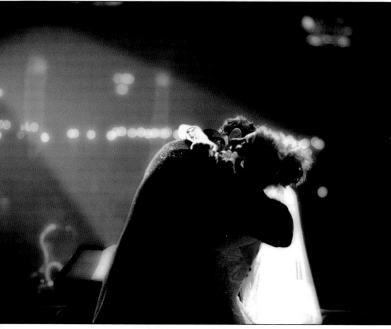

TOP LEFT—Joe Buissink has been known to work in a Zen-like state of concentration for hours at a time when photographing a wedding. This state of focus gives him potent powers of observation. This fleeting image of the bride would have gone unnoticed by most, yet Joe turned it into an award-winning shot. **ABOVE**—Anticipation and preparation are directly linked. The more the photographer knows what will happen next and where, the more prepared he will be. For this image, Jerry Ghionis knew how and where the spotlight would fall and was in position to capture a romantic, moment. **TOP RIGHT**—Becker made this image of the newlyweds by concentrating on the movement and expression of the couple. While the predictive autofocus tracked focus on the couple, Becker waited for the perfect moment.

The ability to know what comes next relies in part on knowing the intricacies of the event and the order in which events will occur, but it is also the result of experience—the more weddings one photographs, the more accustomed one becomes to their rhythm and flow. It is also a function of clearly seeing what is transpiring in front of you and being able to react to it quickly.

Capturing the Peak of Action. The great sports photographer has learned to react to an event by anticipating where and when the exposure must be made. There is an ebb and flow to every action. Imagine a pole-vaulter, for example, who at one moment is ascending and the next moment is falling—somewhere in between there is an instant of peak action that the photographer strives to isolate. Even with motor drives capable of recording six or more images per second, it is not a question of blanketing a scene with high-speed exposures, it is know-

ing when to press the shutter release. With a refined sense of timing and good observational skills, you will drastically increase your chances for successful exposures in wedding situations.

Reaction Time. There is an intangible aspect to reaction time that all photographers must hone, and that is *instinct*—the internal messaging system that triggers reaction. It is a function of trusting yourself

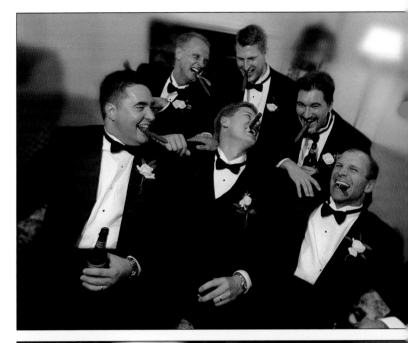

RIGHT—Scott Eklund prides himself on his timing and reflexes, but also his preparation. This image, recorded with straight flash and then selectively blurred in Photoshop, is a classic wedding-day moment. **BELOW**—In this image, called *The Kiss,* Stuart Bebb wanted the veil to do something interesting in the breeze, which it did. The lovely S curve leads to the couple but helps the eye wander through the fascinating details in the image. **BOTTOM RIGHT**—A burst of emotion may be so fleeting that it comes and goes before the photographer can even react. By being ever-ready, Mercury Megaloudis reacts to scenes like this with the quickness of a cat. He made this image with a Canon EOS D30 at $^1\!/_{500}$ second to freeze all subject movement.

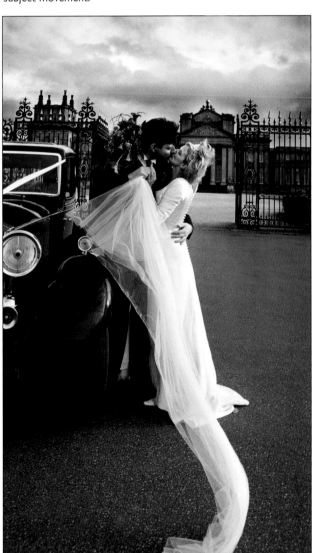

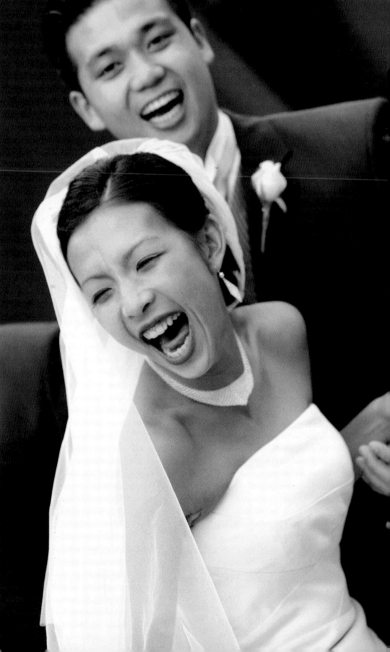

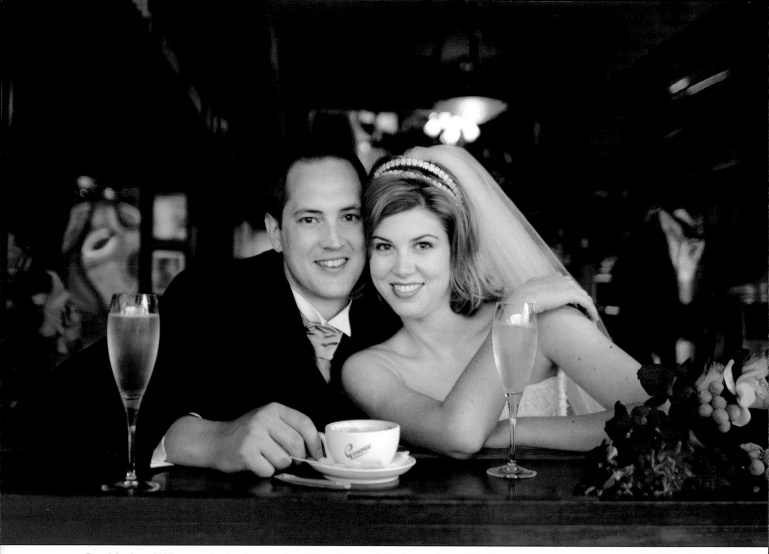

David Anthony Williams maintains that good wedding photography isn't complicated, it's about expression, interaction, and life. Here, David combined a classic triangular-shaped composition, a favorite pub, champagne so real you can taste it, and the single best element, the emotional link between the bride and groom.

to translate input into reaction—analyzing what you see and are experiencing into the critical moment to hit the shutter release. Master wedding photojournalist Joe Buissink trusts his analytical powers of concentration and observation, saying, "Trust your intuition so that you can react. Do not think. Just react or it will be too late."

Vision. Skilled photographers have a sense of vision, noticing things that others don't. Australian photographer David Anthony Williams, who is quite articulate on the subject says, "Good wedding photography is not about complicated posing, painted backdrops, sumptuous backgrounds, or five lights used brilliantly. It is about expression, interaction, and life! The rest is important, but secondary."

Williams throws himself into the day with the zest of a primary participant. He says, "I just love it when people think I'm a friend of the couple they just haven't met yet—one who happens to do photography." This level of involvement, plus preparation, and basic photographic skills, leads to great pictures.

Style. Today's wedding coverage reflects an editorial style, pulled from the pages of today's bridal magazines. Noted Australian wedding photographer Martin Schembri calls it a "a clean, straight look." If you study these magazines you will notice that there is often very little difference between the advertising photographs and the editorial ones used to illustrate articles. Based on an understanding of consumer trends in wedding apparel, the photographer can be better equipped to understand what the bride wants to see in her photographs.

As a result of these trends, Schembri, who produces elegant, magazine-style digital wedding al-

bums, is as much a graphic designer as he is a top-drawer photographer. Schembri assimilates design elements from the landscape of the wedding—color, shape, line, architecture, light, and shadow—and he also studies the dress, accessories, color of the bridesmaid's dresses, etc., and then works on creating an overall work of art (i.e., the album) that reflects these design elements on every page.

Digital wedding photographers take style to the next level. Michael Schuhmann, for example, says of his work, "It's different—it's fashion, it's style. I document a wedding as a journalist and an artist, reporting what takes place, capturing the essence of the moment."

People Skills. Any wedding photographer—journalistic or traditional—needs to be a "people person," capable of inspiring trust in the bride and groom. Generally speaking, wedding photojournalists are more reactive than proactive, but they cannot be flies

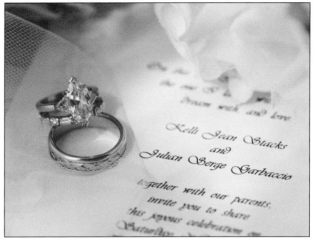

One of the reasons wedding photography is so challenging is that it brings together all of the photographer's interpersonal skills as well as technical skills. Here, Fran Reisner created this lovely detail of the wedding day including the wedding rings, the invitation and flowers, and a bit of the veil. With very little depth of field, the image has a soft and dreamlike feeling. This type of picture will enhance any album.

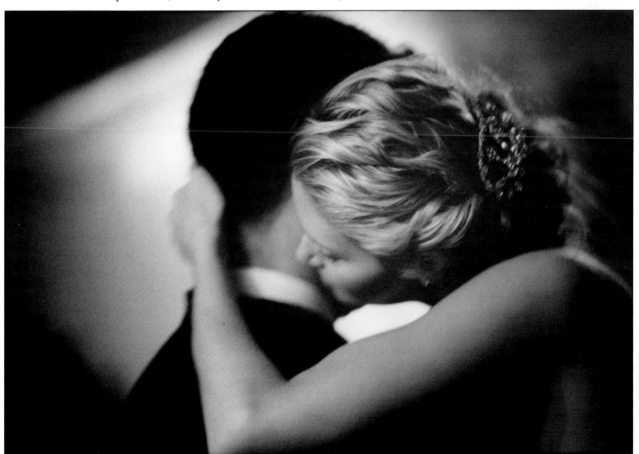

With almost no light present in the scene, Joe Buissink created this romantic moment of the bride and groom. Joe is aware of these subtle and fleeting moments that most photographers would not even see. In fact, most would ignore this scene because of the extremely low light. The title of the photo is *At Last*.

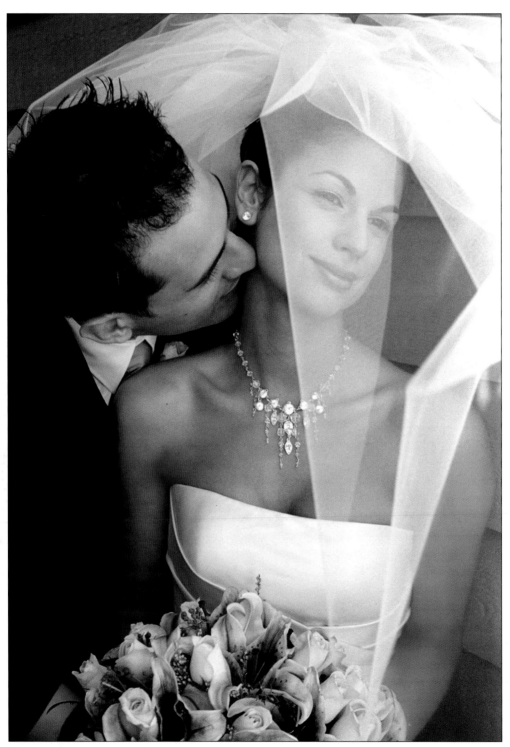

Yervant Zanazanian created this fabulous portrait in the shade of a house. Note the beautifully content glow on the bride's face. Yervant's technical and people skills as a photographer are evident in every frame of his wedding coverage.

on the wall for the entire day. Interaction with the participants at crucial and often very stressful moments during the wedding day is inevitable, and that is when the photographer with people skills really shines.

Wedding photographer Joe Buissink has been called a "salt of the earth" person—a personality type that makes his clients instantly like and trust him.

That trust leads to complete freedom to capture the event as he sees it. It also helps that Buissink sees the wedding ceremonies as significant and treats the day with great respect. Buissink says of his people skills, "You must hone your communication skills to create a personal rapport with clients, so they will invite you to participate in their special moments." He also stresses the importance of being objective and unen-

cumbered. "Leave your personal baggage at home," he says. "This will allow you to balance the three principle roles of observer, director, and psychologist."

Kevin Kubota, a successful wedding and portrait photographer from the Pacific Northwest, always encourages his couples to be themselves and to wear their emotions on their sleeves, an instruction that frees the couple to be themselves throughout the entire day. He also tries to get to know them as much as possible before the wedding and also encourages his brides and grooms to share their ideas as much as possible, opening up the dialogue of mutual trust between client and photographer.

Through my association with Wedding and Portrait Photographers International and *Rangefinder* magazine, I talk to hundreds of wedding photographers each year, and a common thread among the really good ones is an affability and a likability. They are fully at ease with other people and, more than that, they have a sense of personal confidence that seems to inspire trust.

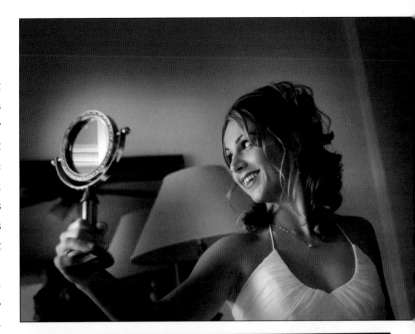

WHAT TO LOOK FOR

Narrative. The goal of the digital wedding photographer is to become a storyteller and capture the reality of the situation, with as little interference as possible. Linking the spontaneous events of the day forms the wedding-day story, which is what the modern bride wants to see in her wedding coverage. While such coverage reveals flaws, care is taken not to depict these in a harsh or otherwise unappealing way. The record of the day should be a sensitive portrayal of the events that highlight the emotion elicited.

The wedding day is a collection of short stories that, when pulled together, form a narrative of the entire day. A good storyteller, therefore, is aware of the elements of good narrative—constructing stories

TOP—Joe Photo captured this delightful moment as the bride made her final preparations. Although the photo looks posed it doesn't really matter, because it is an interesting element in the overall wedding-day story. **RIGHT**—Frances Litman captured this wonderful vignette of a young wedding photographer seemingly confused about the difference between f-stop and shutter speed.

ABOVE—Mercury Megaloudis [Happy Greeks] The name of this wonderful wedding image is *Happy Greeks* by Mercury Megaloudis. It is the kind of image you certainly can't plan for, but should be prepared for nonetheless. LEFT—We've all seen the cliché wedding shot of the bride looking in the mirror putting on her lipstick. This one is different, however. In the bride's eyes you can see apprehension, fear, and uncertainty—emotions that would not be uncommon on her wedding day. The result is more than a cookie-cutter wedding shot, it's a story unfolding with depth of character. Photograph by Fran Reisner.

According to award-winning wedding photographer Charles Maring, a good story includes many details that go unobserved by most people—even those attending the event. He says, "Studying food and wine magazines, fashion magazines, and various other aspects of editorial images has made me think about the subtle aspects that surround me at a wedding. Chefs are preparing, bartenders are serving, waiters are pouring champagne or wine. My goal is to bring to life the whole story from behind the scenes,

that have a beginning, a middle, and an end. Also of importance are the qualities that make a story entertaining to experience: emotion, humor, tension, resolution, and so on.

to the nature around the day, to the scene setters, to the blatantly obvious. In short, to capture a complete story."

Emotion. The ability to immerse oneself in the events of the day is key. The photographer must be able to feel and relate to the emotion of the event. Arizona wedding specialist Ken Sklute is a devotee of the concept of immersion, believing that emotion is the heart of every great picture. Celebrated wedding photographer Joe Buissink, who shoots about half of his wedding coverage digitally, has described this as "being in the moment," a Zen-like state that at least for him is physically and emotionally exhausting. Buissink stays in the moment from the time he begins shooting and will stay in that mode for six to eight hours.

Uniqueness. No two weddings are ever the same, and it is the photographer's responsibility to make every wedding album unique. This is the fun part for the photographer. With the abandonment of the cookie-cutter style of posed portraits, every wedding is a new experience with all new challenges for the wedding photographer.

Part of what makes the wedding unique is the emotional outpouring among the participants. Since the digital wedding photographer is primarily a photojournalist and, by and large, does not pose the participants, these moments will be captured in a natural and genuine way. This is one of the primary means of preserving a wedding's uniqueness.

ASSISTANTS

While the photojournalist may possess extraordinary powers of observation, razor-sharp timing, and lightning reflexes, he or she may still miss the moment by virtue of someone getting in the way or one of the principals in the scene turning away at the last moment. Even with the best-laid plans, some great shots still get away.

Assistants can run interference for you, downloading memory cards so that they can be reused, burning CD backups on the laptop, organizing guests for group shots, taking flash readings and predetermining exposure, taping light stands and cords securely with duct tape, and a thousand other chores. They can sur-

vey your backgrounds looking for unwanted elements, and they can act as a mobile light stand, holding your secondary flash for back or side-lighting. Assistants also make good security guards against photographers' gear "disappearing" at weddings. An

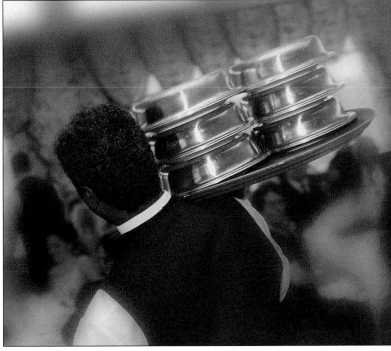

TOP—The most difficult types of wedding images involve lots of people acting spontaneously. If you look closely at this photograph, there are countless stories within the story going on. Photograph by Jerry Ghionis. **ABOVE**—Charles Maring creates lots of different types of shots for his albums, like this shot of the waiter serving dinner. The net result is a wider canvas for the wedding story.

assistant is another set of eyes whose priority it should be to safeguard the equipment.

An assistant must be trained in your unique brand of photography so that he or she knows how to best help you. A good assistant will be able to anticipate your needs and help prepare you for upcoming shots. An assistant should be completely familiar with your "game plan" and know everything that you know about the details of the day.

Most assistants go on to become full-fledged wedding photographers. After you've developed confidence in an assistant, he or she can help you photograph the wedding—particularly at the reception when there are too many things going on at once for one person to cover. Most assistants will try to work for several different wedding photographers to broaden their range of experience. It's a good idea to employ several assistants so that if you get a really big job you can use more than one. Or, if one is unavailable, you have a backup.

Many husband-and-wife teams cover a wedding together, creating different types of coverage (formals *vs.* reportage, for example). In many cases, even these duos also use assistants to broaden their coverage into a real team effort.

PREPARATION

The better prepared the photographer is, the better the pictures will be. It's no different than a sports photographer knowing the status of every player and the tendencies of each team before the game. Similarly, the wedding photographer must know the clients, and must know the detailed plans for the day—both the wedding and the reception. Based on this information, the photographer will be able to determine the best ways to cover those events, choreographing his or her movements to ensure optimum positioning for each phase of the wedding day. The confidence that this kind of preparation provides is immeasurable. (Keep in mind, you also need to put in the time—arriving early and leaving late is one way to be assured you won't miss great shots.)

Visiting each venue is an excellent way to prepare yourself for the day. You should also talk to the other vendors who will be working at the wedding—the

Deanna Urs knew that this bride would spend a few moments with her long-time pal and waited for the right moment. With a sun-filled room, Deanna fired a flash from camera position, set to a stop less than the available light, to fill in the shadows but preserve the ambient room light.

florist, caterers, band or disc jockey, etc. Another good practice is to schedule an engagement portrait. This has become a classic element of modern-day wedding coverage, allowing the couple to get accustomed to the photographer's rhythms and style of shooting before the wedding day. The experience also helps the threesome get to know each other better, so that the photographer doesn't seem like an outsider on the wedding day.

Joe Photo
IMAGE GALLERY

Joe Photo is not only good, he was also lucky enough to land the wedding assignment of a lifetime. After seeing his images of their engagement party, the couple was so pleased that they hired him to accompany them on a two-week, round-the-world wedding adventure. The entire wedding party consisted of just four people: Joe and his wife Ingrid, and the bride and groom. The bride brought five different wedding gowns, featuring creations from Ulla-Maija, Oscar de la Renta, Badgley Mischka, and Vera Wang, as well as some traditional Chinese costumes. The groom carried along two tuxedos, dress shirts, and several suits.

The wedding itself was on the grounds of Chateau de Mirambeau in Miarmbeau, France. From there, the group headed to Venice, Italy where they boarded a ship and then traveled on to Dubrobnik, Croatia. Next, it was on to Ephesus, Turkey; Mykonos, in the Greek Isles; then Athens and Paris. Before embarking, Joe had researched each of the cities, so he knew where to take them to get the best backgrounds at every destination. As it turned out, he never used his flash once, shooting everything by available light.

At each location they made hundreds of photographs with the bride wearing a different wedding gown at each location. Joe photographed an average of three hours a day, except on the wedding day, which took seven hours to cover. Using two Nikon D1X digital cameras, he shot over 5000 exposures of this event. He downloaded the images to a Titanium G4 laptop and edited them daily. He also brought along 8GB of memory cards and a 60GB external hard drive for backup. In the end, he presented the couple with 1600 previews in tastefully designed boxes, which they loved!

In wedding circles, this dream assignment has caused many positive ripples. *Wedding Style* magazine featured Joe's images in a splashy layout and Saks Fifth Avenue, where all the wedding gowns were purchased, also requested a sample album to show its clients.

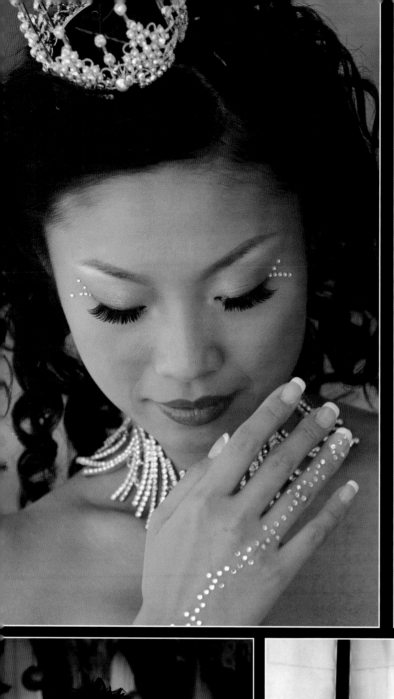
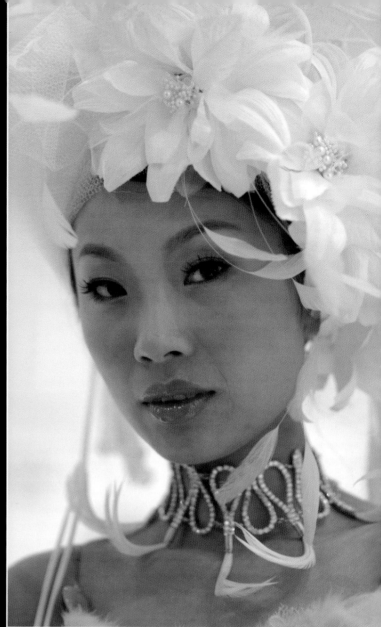

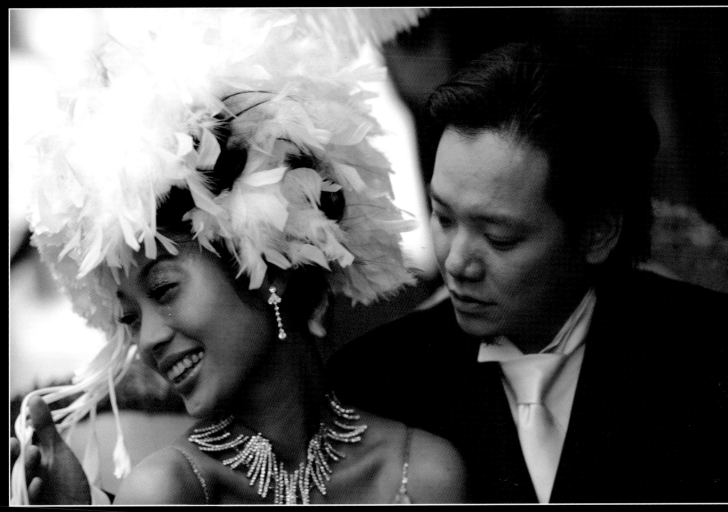
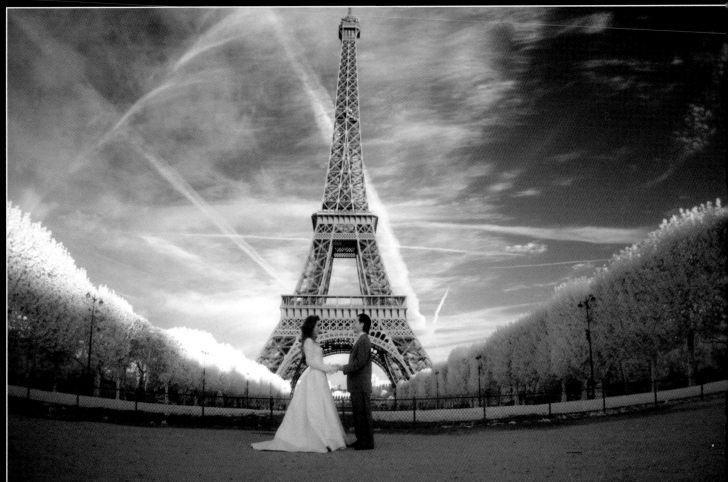

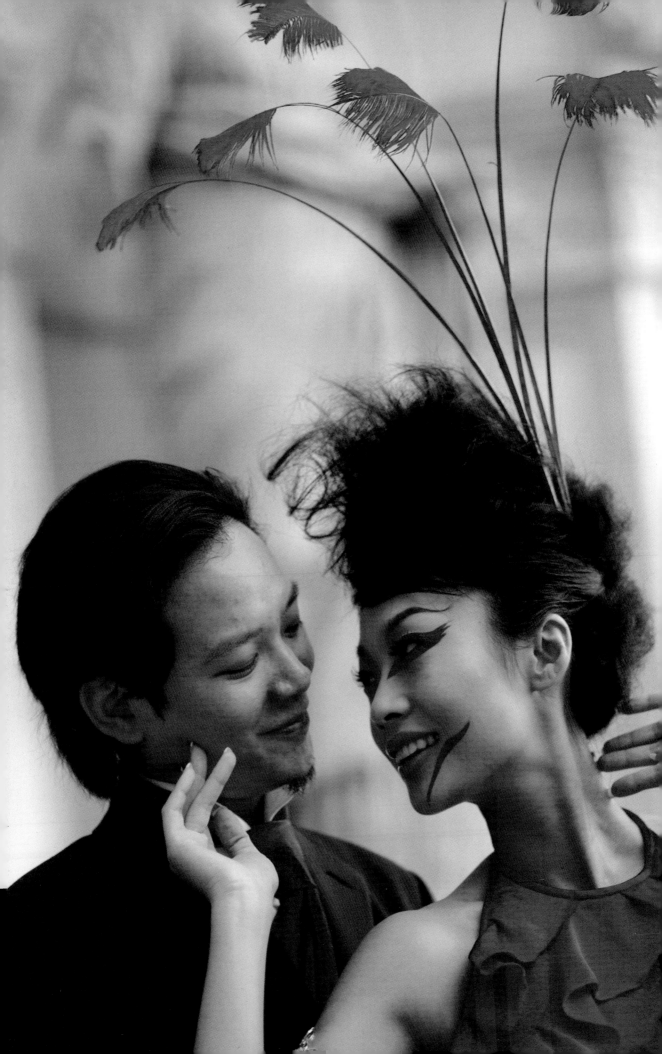

he digital wedding photographer's arsenal includes a lot of sophisticated equipment—from cutting-edge digital SLR cameras to fast, lightweight lenses. Whatever brand or model you choose, however, knowing how to use your equipment quickly and efficiently is key to capturing fleeting moments.

THE DIGITAL SLR

The 35mm DSLR (digital single-lens reflex) camera is the camera of choice for today's digital wedding photographer. The days when only medium format cam-eras were used for wedding photography seem to be at an end. Fast, versatile zoom lenses, cameras that operate at burst rates of six frames per second, amazingly accurate autofocus lens performance, and incredible developments in digital imaging technology have led to the prominence of the 35mm DSLR in wedding photography.

Professional 35mm digital camera systems include a full array of lenses, dedicated flash units, and system

Kevin Kubota shoots only digital, using Nikon D1X cameras and Nikkor lenses. An image like this is not dissimilar from what would be captured on film, except that all of the print manipulations are done in Photoshop—dodging, burning-in, and a slight vignetting on the corners. Kevin also used selective blurring to greatly diffuse the background.

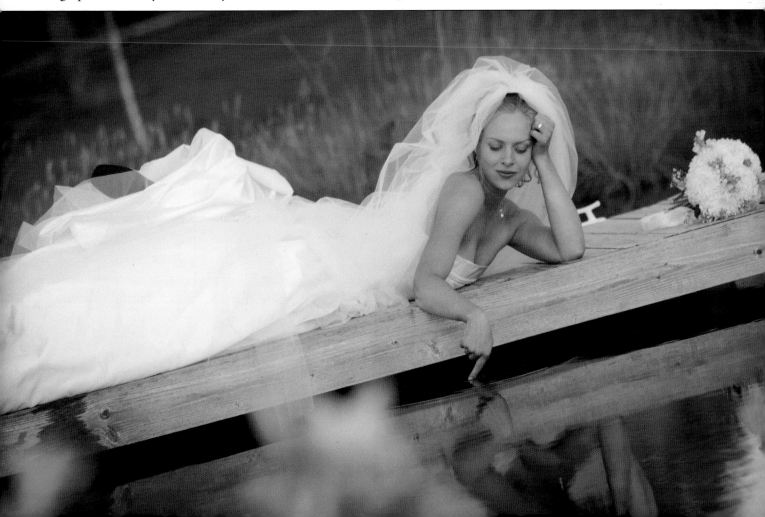

accessories. Currently there are seven full-fledged systems: Canon, Nikon, Olympus, Kodak (which uses Canon or Nikon autofocus lenses), Fuji (which uses Nikon autofocus lenses), Pentax, and Sigma (which uses the radically different Foveon X3 image sensor). Each manufacturer has several models within their product line to meet varying price points. Many of the pre-digital lenses available from these manufacturers for their film cameras also fit the new digital cameras—although usually with a corresponding change in focal length (depending on the size of the image sensor). In addition, a number of lens manufacturers also make AF lenses to fit various brands of digital SLRs. These include Tokina, Tamron, and Sigma.

Since the advent of the DSLR, manufacturers are investing huge sums into product development and engineering, so more advanced, less expensive camera models are appearing every day.

Removable Storage Media. Instead of film, digital cameras store and save digital image files on port-

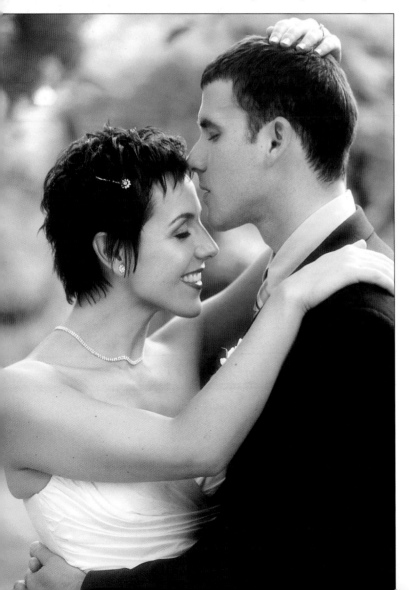

able digital media. As you take pictures, the camera writes the image data to the removable storage device. When the card or drive becomes full, you simply eject it and insert a new one—just like you would change film at the end of the roll.

There are two types of media: flash memory (like CompactFlash [CF] and Memory Sticks) and micro-drives (miniature portable hard drives). Flash memory, which uses no moveable parts, tends to perform better than mechanical hard drives under adverse shooting conditions. Some cameras feature dual slots for different media types, others accept only a single type of card, like CF cards. Obviously, the more options you have to use larger (or less expensive) media, the more flexible the camera will be over time. The most common formats at this time seem to be CF cards (Types I and II) and microdrives.

Removable media are rated and priced according to storage capacity; the more storage capacity, the higher the price. The latest memory card at this writing is the xD card, developed jointly by Fuji and Olympus. The xD card, which uses NAND Flash memory, is very small and provides write speeds up to 3MB per second (MB/s). Currently, the largest capacity xD card is 512MB, but planned capacity is up to 8GB. Various adapters make the cards useable across a wide range of digital cameras.

The write speeds of the different media vary from 1.8MB/s all the way up to 10MB/s. Write speed is a critical function—especially if you plan to shoot RAW files, which are inherently larger than JPEGs. However, the write speed of the media is not the *only* determining factor in how fast information will write from the camera to the storage media. The software used by the camera, file size, and the number of individual files to be written are all determining factors. However, as the crow flies, faster write speed is a desirable quality in storage cards.

Digital images must be uploaded from the removable storage media to a computer. To facilitate this process, a number of digital card readers are avail-

To capture this beautiful backlit moment, Mercury Megaloudis employed fill from a reflector. He then color corrected and selectively softened the image in Photoshop.

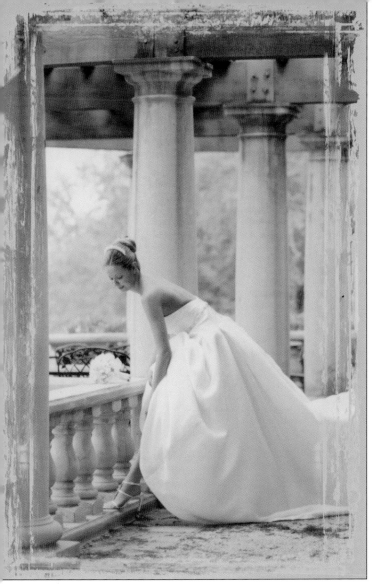

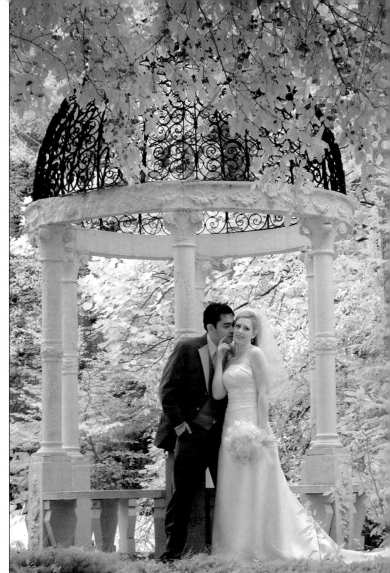

LEFT—Elizabeth Homan used Photoshop to carry the tone of the interior columns outside the borders of the image, creating a striking edge effect that redefines the portrait. **RIGHT**—Using a Nikon Coolpix 950 digital camera and an opaque #87 infrared-pass filter (to block visible light rays but transmit infrared wavelengths), Patrick Rice created this digital infrared image. The Coolpix 950 is one of the few digital cameras with an ineffective infrared cut-off filter, which is used to keep infrared light from striking the imaging chip. Exposures are made using the in-camera meter, but are on the long side because of the density of the #87 filter. A tripod is a necessity for this kind of image.

able—and they are quite inexpensive. Of course, the camera can be connected directly to the computer and the images uploaded in this manner, but using a card reader gives the photographer the ability to load the camera with a fresh card and put it back into action immediately. Card readers feature USB 2.0 or FireWire connectivity, which make uploading incredibly fast. Once the images are safely stored on the computer's hard drive and safely backed up on CD or DVD, the card can be erased, reformatted, and reused.

Image Sensors. Digital cameras use image sensors to record an image. Presently there are two main types: CCD and CMOS sensors. While opinions on the aesthetic performance of the two imaging chips vary from pro to pro, both sensor types provide excellent quality image files.

CCDs (charge-coupled devices) record an image in black & white and then pass the light through an array of red, green, and blue filters (called Bayer filters) to form a color image. The individual filters let only one wavelength of light—red, green, or blue—pass through to any given imaging site (pixel), allowing it to record only one color.

CMOS chips (complementary metal oxide semiconductors), like CCDs, use a mosaic color filter sys-

tem over the photodetectors. Also included on the CMOS imaging chip, however, is analog signal-processing circuitry that collects and interprets signals generated by the photodiode array. After a raw image has been obtained, it is amplified and converted into the standard red, green, and blue (RGB) format through interpolation systems. This make them more energy-efficient (an important consideration, since digital cameras are big-time battery consumers) and somewhat less expensive to manufacture.

Although full-frame image sensors now exist, most digital cameras are manufactured with imaging sensors that are smaller than the full-size 35mm frame of 1 x 1.5 inches. While the chip size does not necessar-ily affect image quality or file size, it does affect lens focal length. The effect of a smaller size image sensor is to change the effective focal length of existing lenses. With sensors smaller than 1 x 1.5 inches, all lenses get effectively longer in focal length. This is not usually a problem where telephotos and telephoto zooms are concerned, since the maximum aperture of the lens doesn't change, but when your expensive wide-angles or wide-angle zooms become significantly less wide on the digital body, it can be somewhat frustrating. For example, with a 1.4x lens focal-length factor, a 17mm lens becomes a 24mm lens.

Two different developments are occurring at this writing. First, chip sizes are getting larger. Several

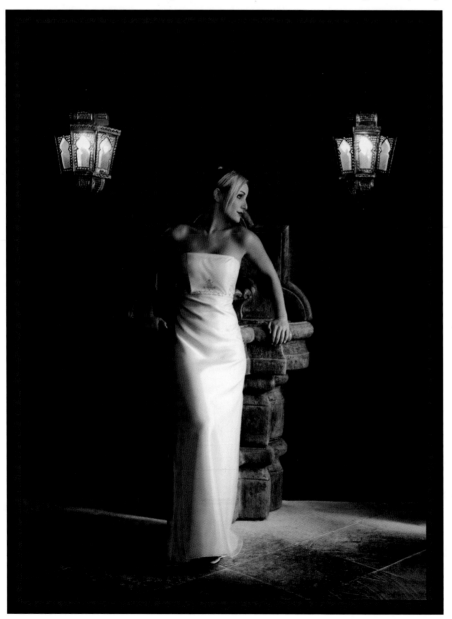

Deborah Ferro was an artist before she became a photographer. Unfamiliar with the digital ways of creating photo-graphic fine art, she studied with some of the finest photographers, learning more and more until, now, she is earn-ing international awards for her work. She loves the rich, saturated colors of the old hotels in Jacksonville, FL, where she lives with her husband Rick (also an award-winning photographer). Here, window light and incandescent light combine in a striking but uncon-ventional bridal portrait.

Tony Florez has been creating unique and dramatic wedding images for 22 years. He photographs with both film and digital Nikon cameras and manipulates each final image in Photoshop. Here, he captured a beautiful private moment that the bride will treasure for a lifetime.

digital SLRs are now available with full-size 1 x 1.5-inch imaging chips, meaning that there is no change to the effective focal lengths of your lenses. Second, camera manufacturers committed to smaller chip sizes have started to introduce lens lines specifically designed for digital imaging. The circle of coverage (the area of focused light falling on the film plane or digital-imaging chip) is smaller and more collimated (keeping the light rays parallel) to compensate for the smaller chip size. Thus, the lenses can be made more economically and smaller in size, yet still offer as wide a range of focal lengths as traditional lenses.

Sensitivity/ISO Range. Most digital camera systems feature an ISO sensitivity range from ISO 100 to 800 or, in some cases, 1600. Some cameras also offer an ISO 3200 setting as a special custom function. Obviously, the wider the gamut of sensitivity, the more useful the camera system will be under a wide range of shooting conditions.

Burst Rate. Unlike film cameras, which use a motor drive to propel the film past the focal plane, there is no film-transport system in a digital camera. The number of frames per second (fps) the camera can record is dictated by a number of factors, includ-

Rick Ferro, well known for his formal, classical wedding portraits, loves to work in afternoon light with reflectors, creating studio-like light on his subjects. Here a bride and groom were captured in historic St. Augustine, FL.

ing its write speed (how fast the image can be written to the storage media), file type, and file size. RAW files are larger than JPEGs, for example, and take longer to record, thus the burst rate is slower when shooting RAW files than it is when shooting JPEGs. Typical burst rates range from 2.5fps for up to six sequential shots, all the way up to 8fps for up to 40 sequential shots. The spec to look at is the number of consecutive frames that can be captured in a single burst (6, 8, 10, etc.) and the frames-per-second operation (3fps up to 8fps).

LCD Monitor. The size and resolution of the camera's LCD screen are important, since these screens are highly useful in determining if you got the

shot or not. LCD screens range from about 1.8 inches to 2.5 inches, and screen resolution ranges from around 120,000 dots to 220,000 dots.

Playback. As important as the physical specifications of the LCD is the number of playback options available. Some systems let you zoom in on the image to inspect details. Some let you navigate across the image to check different areas of the frame in close-up mode. Some camera systems allow you a thumbnail or proof-sheet review. Some of the more sophisticated systems offer a histogram (to gauge exposure) and highlight-point display to determine if the highlight exposure is accurate throughout the image.

Lens Conversion Factor. As noted above, if the camera's sensor is smaller than a standard 35mm frame, a lens conversion factor will apply. How great this factor is will control how much the effective focal length of your lenses will be increased. With a 1.6x lens-conversion factor, for example, a 50mm lens would become an 80mm lens. (Lens speed, as mentioned above, does not change. Your f/1.8 lens would still be an f/1.8 lens.)

Effective Pixels. This is the rated size of the maximum image the sensor can record. It can be listed in terms of millions of pixels or megapixels (MP). Obviously, the higher the number of pixels, the larger the file and print size you can create from that file. Some manufacturers also give the specification in terms of the total file size—11MB (megabytes) or 18MB TIFF, for example, since many people think in these terms. It is important to note that some manufacturers use processing algorithms to interpolate resolution. For example, the chip size might be 6MP, yet the standard file size is 12MP because of the software interpolation.

File Types. The different types of files that DSLRs typically record are RAW files, JPEGs, and TIFF files. JPEGs allow you to shoot more quickly because there is file compression inherent in the JPEG format.

RAW files provide the maximum amount of information in the captured image. The TIFF format, however, is the most widely used in digital photography. It supports the RGB, CMYK, grayscale, Lab, and Indexed Color mode, and features lossless compression (called LZW), so the image quality does not degrade when the file is repeatedly opened and closed. (In Photoshop, TIFF files may now also be compressed using lossy JPEG compression when smaller file sizes are required.)

PC Terminal. Some of the lower-priced DSLRs might seem like a bargain—until you realize they don't include professional features like a PC terminal for connecting to electronic studio flash.

Shutter Lag Time. This is a specification most camera manufacturers don't provide in their literature, but it is important to know before making a purchase. This is the length of time between when you press the shutter release and when the camera actual-

ly fires. Consumer and prosumer cameras (consumer cameras with pro features) have substantially longer shutter response times than professional systems, which are almost instantaneous. Even with professional models, though, it is worthwhile to test out each camera in various modes to see the differences between various camera models. Shutter lag time will directly affect the camera's burst rate. Rates of shutter release delay time are usually given in milliseconds (ms) if the spec is even given. An average shutter lag time would be in the area of 90ms.

Lens Capability and Accessories. If you're like most professionals, you've already invested heavily in one pro 35mm SLR system. Trading in all those lenses and accessories and changing to a different brand of camera would require some compelling arguments. Will your current lenses fit the DSLR, and will all of their features be useable on the digital camera body? Know the answer before you invest.

Dimensions/Weight. As with any camera system, ergonomics are extremely important—especially to the wedding photographer who will be working for hours on end handholding the camera with a variety of lenses. Try it out, since it might be quite different than your same brand film camera.

Battery Power. So, where's the motor drive? It's been turned into a battery pack. Since you don't need motorized film transport, there is no motor drive or winder, but the cameras still look the same because the manufacturers have smartly designed the auxiliary battery packs to look just like a motor or winder attachment. While most of these cameras run on AA-size batteries, it is advisable to purchase the auxiliary battery packs, since most digital camera systems (especially those with CCD sensors) chew up AAs like jelly beans. Most of the auxiliary battery packs used on DSLRs use rechargeable lithium-ion batteries.

Price. It's not necessarily the price of the flagship camera in a manufacturer's product lineup that's important, but rather it's the range of prices. Many photographers have decided to purchase several top-of-the-line DSLRs and then several of the lower-priced models from the same manufacturer for back-up and assistant's cameras. These backups still take the same lenses and removable media cards but are less expensive than the top-of-the-line cameras.

White Balance. White balance controls the color balance of the recorded image. It can be set individually for each shot you make (like applying a color-correction filter). Some manufacturers offer a wide range of white-balance options that correspond to a range of color temperature settings (in Kelvin degrees). Others use more photographer-friendly terms like "afternoon shade." In addition, virtually all of the cameras feature an automatic white-balance setting, which allows the camera to sense and determine the best white-balance setting. Most also include settings for fluorescent and incandescent lighting. Custom functions allow you to create your own unique white-balance settings to correspond to certain known shooting conditions or mixed light conditions.

Vladimir Bekker shoots upscale weddings all over the world. As a former architectural student, he believes that the architectural details should be photographed well, as they are an integral part of each wedding. Wherever he travels, he lugs portable quartz-halogen lights and stands. Here, he combines his lights with the available room lighting, in perfect balance, so that the room and its incredible ceiling are almost as important to the photograph as the bride and groom.

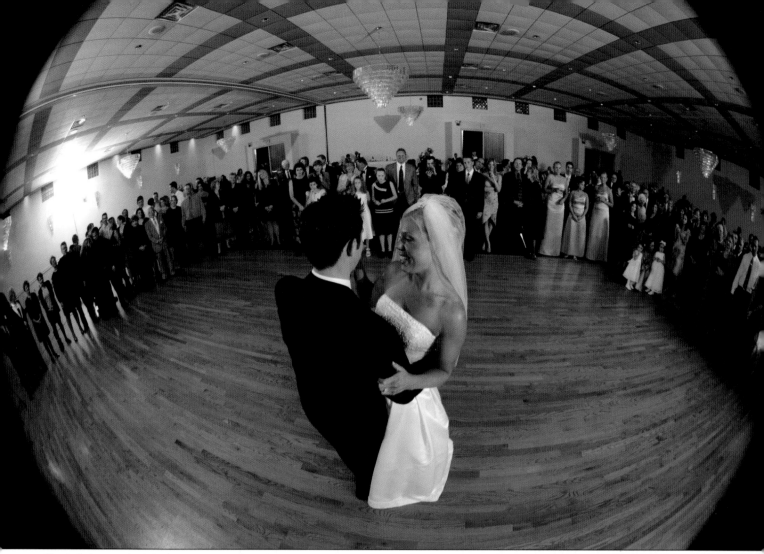

Claude Jodoin created this image using an 8mm Sigma f/4 full-frame fisheye lens on a Canon EOS 10D digital camera. The lens, because of the focal-length factor, no longer functions as a full-frame fisheye, but it still produces the fisheye effect. If the lens had been used on a camera with a full-size 35mm imaging sensor, there would have been no apparent change in focal length and the full-circle fisheye effect would be visible.

Obviously, the more flexibility you have in setting the white-balance, the less color correction you will have to perform later in Photoshop. Some camera systems even offer a white-balance bracketing feature.

LENSES

Focal Length. The lenses of choice for today's digital wedding photographer seem to be the Nikon 80–200mm f/2.8 and the Canon 70–200mm f/2.8. These are very fast, lightweight lenses that offer a wide variety of useful focal lengths for both the ceremony and reception. They are internal focusing, meaning that the autofocus is lightning fast and the lens does not change its physical length as it is zoomed or focused. At the shortest range, 70mm or 80mm, this lens is perfect for full-length and three-quarter-length portraits. At the long end, 200mm, it is ideal for tightly cropped candid coverage or head-and-shoulders portraits.

These zoom lenses also feature fixed maximum apertures, which do not change as the lens is zoomed. This is a prerequisite for any lens to be used in fast-changing conditions. Variable maximum apertures, such as f/2.8 to f/3.5, while providing a cost savings, are not as functional nor as bright as a faster, fixed-aperture lens like an f/2.8. Fast fixed focal-length lenses will get lots of use, as they afford many more available light opportunities than slower lenses. If you can avoid using flash, which naturally calls attention to itself, you should generally do so.

Other popular lenses include wide angles, both fixed focal-length lenses and wide-angle zooms. Focal

ABOVE—The light is dim, the bride and groom are moving toward the camera and the expression on the bride's face is priceless. Rather than concentrating on the quickly changing focus, the photographer must concentrate on the expression and composition. Predictive auto-focus is a technology that allows the photographer to do just that. Photograph by Charles Maring. **FACING PAGE**—Some photographers disdain the use of zoom lenses, preferring prime focal lengths. Zooms (even good ones) produce more flare than prime (fixed focal-length) lenses. Therefore, purists, who only want to use the very finest glass, will forego the convenience of zoom lenses in favor of heightened image quality. Photograph by Mike Colón.

lengths from 17mm to 35mm are ideal for capturing the atmosphere as well as for photographing larger groups.

At the other end of the focal-length spectrum, many wedding photojournalists use ultrafast telephotos, like 300mm f/2.8 or f/3.5 lenses. These lenses, while heavy, are ideal for working unobserved and can isolate some wonderful moments. Even more than the 80–200mm lens, the 300mm throws backgrounds beautifully out of focus and, when used wide open at a relatively close camera-to-subject distance, provides a beautifully thin band of focus—ideal for isolating image details.

Another favorite lens is the 85mm (f/1.2 for Canon; f/1.4 or f/1.8 for Nikon), which is a short

telephoto with exceptional sharpness. This lens gets used frequently at receptions because of its speed and ability to throw backgrounds out of focus, depending on the subject-to-camera distance.

One should not forget about the 50mm f/1.2 or f/1.4 "normal" lens for digital photography. With a 1.4x focal-length factor, that lens becomes a 70mm f/1.2 or f/1.4 lens that is ideal for portraits or groups, especially in low light. The close focusing distance of this lens also makes it an extremely versatile wedding lens.

Mike Colón, a talented photographer from the San Diego area, uses prime lenses (not zooms) in his wedding coverage and shoots at wide-open apertures most of the time to minimize background distrac-

In open shade, as seen here, the light is overhead. Unless you use some means of shadow fill-in, the lighting can be almost as bad as shooting at noon in bright sun. Here, Charles Maring used an almost imperceptible flash at the camera position (1½ stops less than the daylight exposure) to fill in the facial shadows and eyes of this pleasant group.

tions. He says, "The telephoto lens is my first choice because it allows me to be far enough away to avoid drawing attention to myself, but close enough to clearly capture the moment. Wide-angle lenses, however, are great for shooting from the hip. I can grab unexpected moments all around me without even looking through the lens."

Autofocus. Autofocus (AF), once unreliable and unpredictable, is now extremely advanced. Some cameras feature multiple-area autofocus so that you can, with a touch of a thumbwheel, change the AF sensor area to different parts of the viewfinder (the center or outer quadrants). This allows you to "de-center" your images for more dynamic compositions. Once accustomed to quickly changing the AF area,

this feature becomes an extension of the photographer's technique.

Using autofocus with moving subjects used to be an almost insurmountable task. While you could predict the rate of movement and then focus accordingly, the earliest AF systems could not. Now, however, almost all AF systems use a form of predictive autofocus, meaning that the system senses the speed and direction of the movement of the main subject and reacts by tracking the focus of the moving subject. This is an ideal feature for wedding photojournalism, where the action can be highly unpredictable.

A new addition to autofocus technology is dense multi-sensor-area AF, in which an array of AF sensor zones (up to 45 at this writing) are densely packed

within the frame, making precision focusing much faster and more accurate. These zones are user selectable or can all be activated simultaneously for the fastest AF operation.

INCIDENT FLASHMETER

A handheld incident flashmeter is essential for working indoors and out, but particularly crucial when mixing flash and daylight. It is also useful for determining lighting ratios. Flashmeters are invaluable when using multiple strobes and when trying to determine the overall evenness of lighting in a large-size room. Flashmeters also work as ambient incident-light meters, meaning that they measure the light falling on them and not light reflected from a source or object (as an in-camera meter does).

WALLACE EXPODISC

An accessory that digital pros swear by is the Wallace ExpoDisc (www.expodisc.com). With the ExpoDisc attached to your lens like a filter, the device provides perfect white balance and accurate exposures whether you are shooting film or digital. The company also makes a professional model that lets you create a warm white balance at capture.

LIGHTING EQUIPMENT

On-Camera Flash. These days, on-camera flash is used sparingly at weddings because of its flat, harsh light. As an alternative, many photographers use flash brackets, which position the flash over and away from the lens, thus minimizing flash red-eye and dropping the harsh shadows behind the subjects—a slightly more flattering light.

On-camera flash is often used outdoors, especially with TTL-balanced flash-exposure systems. With such systems, you can adjust the flash output for various fill-in ratios, thus producing consistent exposures. In these situations, the on-camera flash is most frequently used to fill in the shadows caused by daylight, or to match the ambient light output, providing direction to the light.

Sometimes dual flash units are used to create a softer overall light. Such is the case here as the bride mugs for photographer Claude Jodoin.

Wedding photographers often like to get the bride and groom off to the reception to do a few shots before the throng descends on the reception. Here, Claude Jodoin captured the happy couple in their first dance as husband and wife using bounce flash to illuminate the foreground. With an 18mm lens on a Canon EOS D30, Claude matched the room exposure of $^1/_{15}$ second at f/4 and fired the bounce flash at the same output level (f/4).

Barebulb Flash. One of the most frequently used handheld flash units at weddings is the barebulb flash, an upright-mounted flash tube sealed in a plastic housing for protection. Since there is no housing or reflector, barebulb flash generates light in all directions. This means that you can use all of your wide-angle lenses with these units.

A barebulb flash acts more like a large point-source light than a small, portable flash. Light falloff is less than with other handheld units, making barebulb flash ideal for flash-fill situations—particularly outdoors. These units are predominantly manual flash units, meaning that you must adjust their intensity by changing the flash-to-subject distance or by adjusting the flash output. For doing candids on the dance floor, many photographers will mount a sequence of barebulb flash units on light stands with ball-head adapters that allow them to fine-tune each light's position.

Remote Triggering Devices. If using multiple flash units to light the reception or dance floor, some type of remote triggering device will be needed to synchronize the units. There are a variety of these devices available, but the most reliable by far are radio remote triggering devices. These transmit a radio signal when you press the shutter release. The signal is then received by individual receivers mounted to each flash. This signal can be either digital or analog. Digital systems, like the Pocket Wizard Plus, are state of the art. Complex 16-bit digitally coded radio signals deliver a unique code, ensuring the receiver cannot be triggered or "locked up" by other radio noise.

The built-in microprocessor guarantees consistent sync speeds even under the worst conditions. Some photographers will use a separate transmitter for each camera being used (for instance, an assistant's camera) as well as a separate transmitter for the handheld flash meter, allowing the photographer to take remote flash readings from anywhere in the room.

Bounce-Flash Devices. Many photographers use their on-camera flash in bounce-flash mode. A problem, however, with bounce flash is that it produces an overhead light. With high ceilings, the problem is even worse—the light, while soft, is almost directly overhead. There are a number of devices on the market to help solve this problem. One is the Lumiquest ProMax system, which allows 80 percent of the flash's illumination to bounce off the ceiling while 20 percent is redirected forward as fill light (solving the overhead lighting problem). The system also includes interchangeable white, gold, and silver inserts as well as a removable frosted diffusion screen.

This same company also offers devices like the Pocket Bouncer, which enlarges and redirects light at a 90-degree angle from the flash to soften the quality of the light and distribute it over a wider area. While no exposure compensation is necessary with TTL flash exposure systems, operating distances are somewhat reduced. With both systems, light loss is approximately 1⅓ stops; with the ProMax system, however, using the gold or silver inserts will lower the light loss to approximately ⅔ stop.

Studio Flash Units. You may find it useful to have a number of studio flash heads with power packs and umbrellas. You can set these up for formals, or tape the light stands to the floor to light the reception. Either way, you'll need enough power (at least 50–100 watt-seconds per head) to light large areas.

The most popular of these type of lights is the monolight, which has a self-contained power pack and usually features an on-board photo cell that triggers the unit to fire when it senses a flash burst. All you need is an electrical outlet to position the flash anywhere. (On location, be sure to pack plenty of gaffer's tape and extension cords, then position everything securely to prevent accidents.) The Dyna-Lite Uni 400JR is a popular make of monolight. This is a compact 3.5-pound, 400 watt-second unit that can be plugged into an AC outlet or used with the Dyna-Lite Jackrabbit high-voltage battery pack. The strobe features variable power output and recycle times, full tracking quartz modeling light, and a built-in slave.

Light Stands. Light stands are an important part of location lighting. You should use heavy-duty stands and always tape them firmly in place. Try to hide them in the corners of the room. The stands should be capable of extension to a height of 12–15 feet, and the lights on them should be aimed down and feathered so that their beams crisscross, making the illumination as even as possible. The lights can be set to backlight the people at the reception and an on-camera flash used to trigger the system.

Direct sun with no fill-in produces too much contrast in the image, so most photographers opt to fill in the shadows with flash. In most situations, the flash is set to output at one stop less than the daylight exposure so that it does not overpower the daylight reading. In this image of the bridal party a long way from being ready, Claude Jodoin used just enough fill flash to open up the shadows throughout.

David Beckstead created this painterly and informal portrait of the groomsmen. The original image was exposed with a 20mm lens at $^1/_{5000}$ second on a Nikon D1X in order to capture as little depth of field as possible. Later, a series of diffusion filters were used and the image was taken down in tonality to resemble a low-key portrait.

Umbrellas. Studio flash units can be used with umbrellas to light large areas of a room. Be sure, however, to focus the umbrella, adjusting the cone of light that bounces into and out of the umbrella surface by moving the umbrella closer and farther away from the light source. The ideal position is when the light fills the umbrella but does not exceed its perimeter. Focusing the umbrella helps to eliminate hot spots as well as maximizing light output.

Reflectors. When photographing by window light or outdoors, it is a good idea to have a selection of white, silver, gold, and black reflectors. Most photographers opt for the circular disks, which unfold to produce a large reflector. They are particularly valuable when making portraits by available light.

BACKUP AND EMERGENCY EQUIPMENT

Lights, Cameras, and Other Equipment. Most seasoned pros carry backups (and double-backups)—extra camera bodies and flash heads, extra transmitters, tons of batteries and cords, double the anticipated number of memory storage cards, and so on. In addition, if using AC-powered flash, extra extension cords, duct tape (for taping cords to the floor), power strips, flash tubes, and modeling lights need to be packed. An emergency tool kit is also a good idea—as is a stepladder for photographing large groups or producing an overall shot.

Batteries. As was mentioned above, DSLRs go through batteries rather quickly. While you may bring along extra memory cards, the truly essential backup item is spare battery packs. Even with quick chargers, you will miss precious photo opportunities if you are waiting around for a battery pack to charge. Spare packs should be fully charged and ready to go—and you should have enough to handle your cameras, your assistant's cameras, and the backup gear.

Marcus Bell
IMAGE GALLERY

Marcus Bell, who did not pick up a camera until he was 20, was named the Australian Wedding Photographer of the Year in 2003 for his work in wedding photojournalism. He has also been named Australia's Fine Art Landscape Photographer of the Year and Editorial Photographer of the Year. The reason he is so adept at such different photographic disciplines is that he is, above all, a documentarian—a first-rate storyteller. Bell says, "One thing I've always believed in is that the content of the image is ultimately the most important factor. If you don't have

that screaming out at you, it won't matter what the light, composition, or tone is like." In short, he believes in the decisive moment and he is very good at isolating that.

Technically speaking, Marcus shoots his weddings with Canon 1Ds bodies and primarily uses three lenses: a Canon EOS 24–70mm f/2.8L, a Canon 70–200mm f/2.8L image stabilizer, and a Canon 35mm f/1.4L fixed focal-length. He likes to shoot at the widest aperture possible and use primarily available light. If flash is needed, he will bounce it. He never uses flash directly on

subjects. He says, "I am always pushing the limits in low light, moving with the subject to avoid camera shake." He always hand-holds the camera, and with the help of the image stabilization lens, he can optimize his good frames in low-light situations.

Most of the time, Marcus uses either a manual exposure setting or aperture-priority AE with an ISO of 400. He captures images in the Adobe RGB 1998 color space at the full-resolution JPEG setting. When photographing portraits, he shoots in the RAW mode. About shooting digitally, he says, "The thing I love about digital photography is the control you have over the image—it enables me to use all aspects of my creativity. I love the speed and accuracy of the Canon 1Ds. The only trade-off is that it can get heavy, especially after photographing for long periods of time. I use Photoshop as I would to hand-print an image; i.e., burning, dodging, etc. I don't use 'special effects' very often; I'm still a big fan of more traditional techniques—applied digitally, of course."

Marcus has trained himself to see light in its many forms, which is probably why he sought to excel at landscape photography, his first love. He soon realized that what he knew about landscapes could be applied to his unique style of wedding photojournalism. "What I was capturing in my landscapes, I could do at weddings." He says further, "We are so lucky; we get invited to one of the most magical days of people's lives, and it's much deeper than how people look. It's about what makes that person or that couple special. Telling a story—beauty, reality."

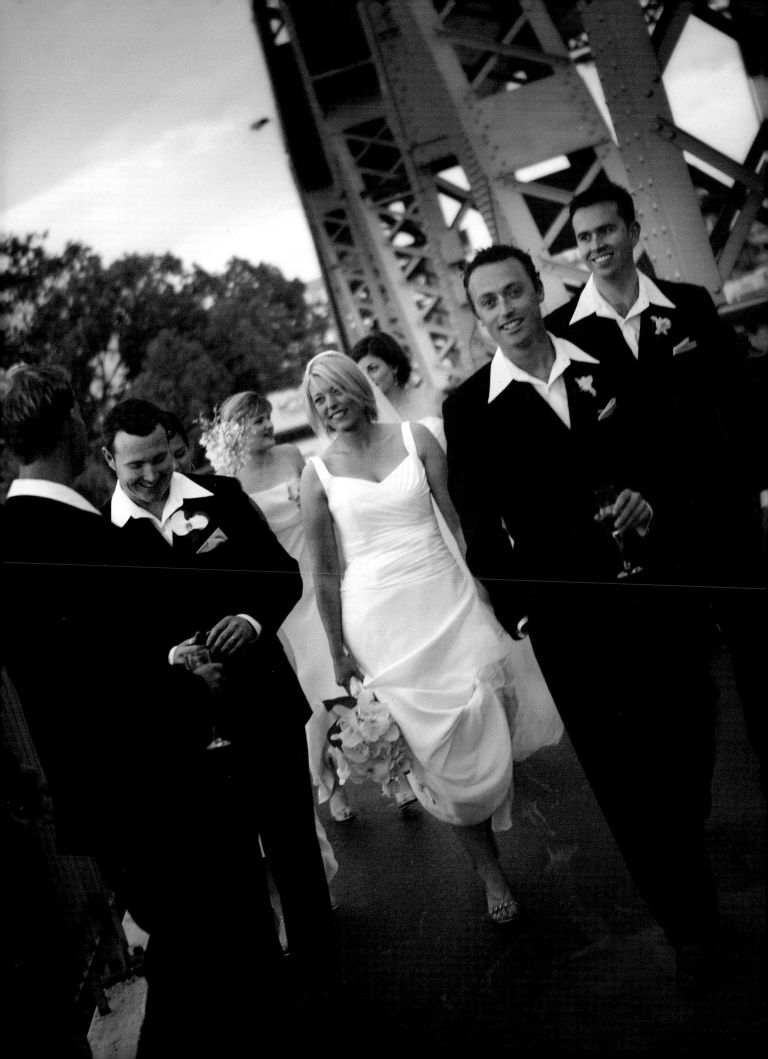

3. SHOOTING TECHNIQUES

Working with digital files is very different than working with negative film. Some photographers liken shooting digital to shooting transparency film—it is unforgiving in terms of its exposure latitude. Underexposed digital files tend to have an excessive amount of noise, and overexposed files lack detail in the highlights. While taking care to create a proper exposure will only make you a better photographer, for those used to ±2 stops of exposure latitude this is a different game altogether. According to Claude Jodoin, a wedding photographer and digital expert, "Your days of overexposing are over! Kiss them goodbye. You must either be right on with your exposures or, if you make an error, let it be only slightly underexposed, which is survivable. Otherwise you will be giving refunds to your clients. Overexposure of any kind is death with digital."

LIGHT METERS

Incident-Light Meter. The preferred type of meter is the handheld digital incident-light meter, which measures light in tenths of a stop. This type of meter does not measure the reflectance of the subjects, but rather it measures the amount of light falling on the scene. Because it is less likely to be influenced by highly reflective or light-absorbing surfaces, like white wedding dresses and black tuxedos, this type of meter yields extremely consistent results.

To use an incident light meter, most professionals recommend that you simply stand where you want your subjects to be, point the meter's dome (hemi-

Stephen Pugh works so quietly that often his subjects don't even know he's there. Here he has captured a lovely—and probably fleeting—wedding-day moment.

sphere) directly at the camera lens, and take a reading. If you can't get to your subject position to take a reading, you can meter the light at your location (if it is the same as the lighting at the subject position).

There is another school of thought on where to point an incident meter, however. Digital guru Don Emmerich insists one must point the meter at the light source and not at the camera lens. Sometimes there is no difference in the readings, but sometimes there is—up to ½ stop difference, which can have a big impact on digital exposures. It is advisable to get into the habit of metering in both ways, make two test exposres at the different settings and view them on the LCD to see which is more accurate.

Reflected-Light Meter. In-camera meters measure light reflected from your scene, giving you a reading designed to render the metered tone as 18 percent gray. If you fill a frame with a white gown, the indicated exposure will actually be two stops off, because it will be calculated to render the white as gray. If you meter a black tuxedo, your exposure settings will be off by two stops in the other direction. Only by using a gray- card reading can you ensure an accurate exposure with a reflected-light meter. With advances in multi-pattern metering, in-camera metering has been vastly improved—however, one must still recognize those situations when a predominance of light or dark tones will unduly influence the exposure reading.

Calibration. Whatever kind of meter you use, it is advisable to run periodic tests on it, cross-checking its readings against another meter or using the gray-card test described on pages 61–62. Like all mechanical instruments, meters can become temporarily out of whack and need periodic adjustment.

EVALUATING EXPOSURE

There are two ways of evaluating exposure of the captured image—by evaluating the image on the camera's LCD screen and by judging the histogram. The LCD monitor provides a quick reference for making sure things are generally okay and for evaluating the sharpness of the focus. When you're in the field, however, you cannot rely completely on the camera's LCD monitor as a guide to proper exposure. LCDs

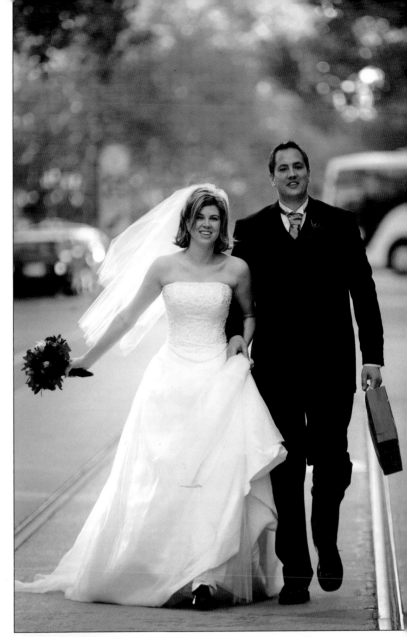

In a normally exposed image with an average range of highlights and shadows, the histogram will have the highest number of pixels in the midtones, as in this image by David Anthony Williams.

vary in brightness and intensity and are usually angle-dependent, making the data difficult to interpret—especially in bright light. The histogram is, therefore, a good alternative tool for evaluating exposure.

The histogram is a graph associated with a single image file that indicates the number of pixels that exist for each brightness level. The range of the histogram represents 0–255 from left to right, with 0 indicating "absolute" black and 255 indicating "absolute" white.

In an image with a good range of tones, the histogram will fill the length of the graph (i.e., it will have detailed shadows and highlights and everything in between). When an exposure has detailed highlights, these will fall in the 235–245 range; when an image has detailed blacks, these will fall in the 15–30 range. The histogram may show detail throughout (from 0–255) but it will trail off on either end.

Histograms are scene-dependent. In other words, the number of data points in shadows and highlights will directly relate to the subject and how it is illuminated and captured. The histogram also gives an overall view of the tonal range of the image and the "key" of the image. A low-key image has its detail concentrated in the shadows (a high number of data points); a high-key image has detail concentrated in the highlights. An average-key image has most of its detail in the midtone range. An image with full tonal range has a significant number of pixels in all areas of the histogram.

In a properly exposed image, the data on the right side of the graph almost reaches the end of the scale but stops a short distance before the end. Overexposure is indicated when the data appears to run off

A low-key image, like this one of a Mercedes decked out with ribbons for the wedding day, has its data points concentrated in the shadow area of the histogram (the left side of the graph). Photograph by Mercury Megaloudis.

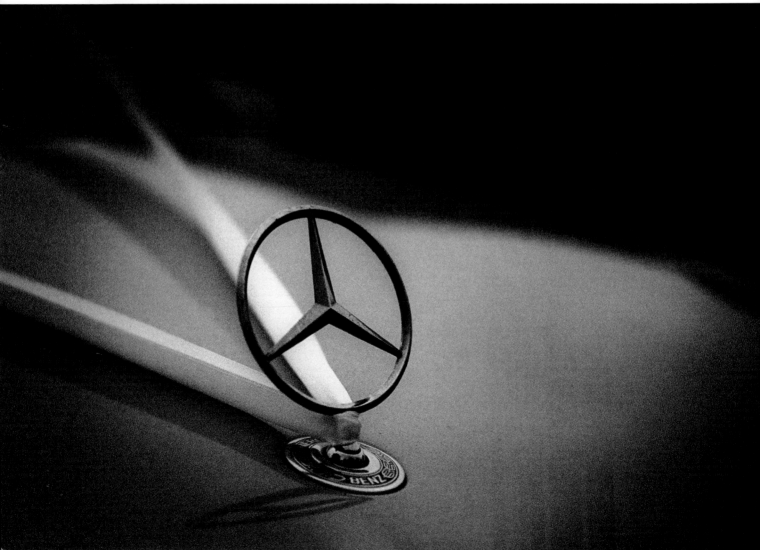

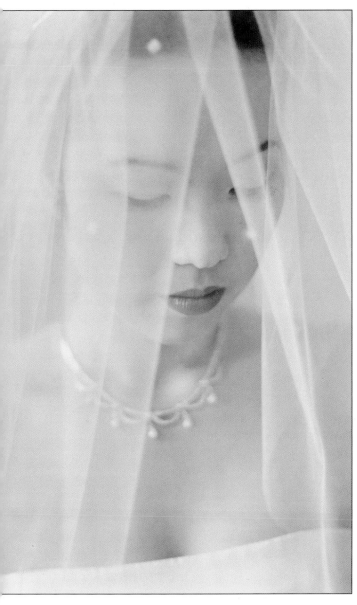

In a high-key image, such as this one by Ann Hamilton, the histogram has most of its image detail concentrated in the highlights (the right side of the histogram).

the right end of the graph, which is the highlight portion of the histogram. This means that the highlights are lacking image detail, tone, and color.

When an image is underexposed, the image information in the histogram falls short of the right side and bunches up on the left side. Although it is true that it is better to have an underexposed image than an overexposed one, an underexposure will still never look as good as a properly exposed image. You can correct for underexposure in Photoshop, but it is time-consuming to adjust exposure in this manner.

A CLEAN IMAGE SENSOR

The image sensor in a digital camera must be kept clean of dust and other foreign matter in order for it

to perform at its optimum level. Depending on the environment in which you do most of your shooting, spots may appear on your images. Cleaning the sensor prior to every shoot will help you to minimize or eliminate such spots in your photos.

While each camera manufacturer has different recommendations for cleaning the sensor, Canon DSLRs actually allow you to set the camera to a sensor-cleaning mode. With the camera's reflex mirror up (a function of the sensor-cleaning mode setting), the company recommends using light air from an air syringe to gently remove any foreign matter. Turning the camera off resets the mirror.

One should realize the image sensor is an extremely delicate device. Do not use propelled air cans to clean a sensor. These contain airborne propellants, which can coat the sensor in a fine mist and worsen the situation.

TESTING YOUR CAMERA'S METERING

Not all digital cameras are created equal. Just as in all things man-made, there are manufacturing and production tolerances that make complex electronic devices dissimilar. It is important to know if your camera's metering system, on which you will rely heavily, is faster or slower than its rated ISO setting.

Here's a simple test, adapted from one devised by Don Emmerich. This test uses a gray card, a card that is 18 percent gray—precisely midway between black and white. Fill the frame with the gray card and meter the scene with the in-camera meter. Expose exactly as

the meter indicates and view the histogram. If the exposure is correct, there will be a single spike (representing the single recorded tone) dead center in the histogram and you will know that the camera is giving you a true, rated ISO setting. If the spike is to the right or left of center, adjust the camera's film speed by ⅓ or ½ of a stop and try again.

If, for example, your initial test was made with an ISO setting of 400 and the spike on the histogram is slightly to the left of center, it means the image is slightly underexposed, so adjust the ISO setting to 320 or 250 and make another frame and review that histogram. If the spike is to the right of center, the frame is overexposed and you will have to reduce the exposure by setting the ISO ⅓ or ½ stop higher (i.e., 500 or 620). Once the spike is properly in the middle of the histogram, you have a perfect exposure for this particular scene and lighting.

So how do you apply what you've learned? If you repeat this test at different ISO settings and under a variet of shooting conditions, you should come up with a reliable factor (or you may find that your meter is perfectly accurate). If, for example, you find that your meter is consistently underexposing your frames by ⅓ stop, add ⅓ stop of exposure compensation. If, on the other hand, the meter is consistently overexposing by ⅓ stop, you can dial in −⅓ stop of exposure compensation.

Perform this same series of tests with your hand-held incident-light meter to make sure all the meters in your arsenal are precisely accurate.

WHITE BALANCE

On a DLSR, the white-balance setting tells the camera how to balance the color correctly when shooting under a variety of different lighting conditions, including daylight, flash, tungsten, and fluorescent lighting. When shooting highest-quality JPEG files, selecting the correct white-balance setting is particularly important; it is less important with RAW files, since these files contain more data than the compressed JPEG files and are easily remedied later (for more on file formats, see the next page).

DSLRs have a variety of white-balance presets, such as daylight, incandescent, fluorescent, and some have the ability to dial in specific color temperatures in Kelvin degrees. These are often related to a time of day. For example, pre-sunrise light might call for a white-balance setting of 2000°K, and heavy overcast light might call for a white-balance setting of 8000°K.

Most DSLRs also have a provision for a custom white balance, which is essential in mixed light conditions, most indoor available-light situations, and with studio strobes. A good system that many photographers follow is to take a custom white-balance reading of a scene where they are unsure of the lighting

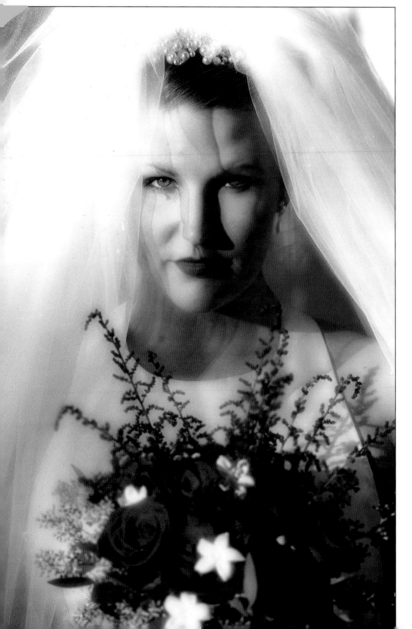

Very strong sidelighting from the sun produced an unusually high amount of contrast. The photographer, Scott Eklund, biased the exposure for the highlights in the skin and let the veil exposure blow out (overexpose). He then introduced diffusion in Photoshop to lower the contrast somewhat, creating a very unusual image.

mix. By selecting a white area and neutralizing it with a custom white-balance setting, you can be assured of a fairly accurate rendition.

Other pros swear by a device known as the Wallace ExpoDisc (www.expodisc.com), which attaches to the front of the lens like a filter. You take a white-balance reading with the disc in place and the lens pointed at your scene. It is highly accurate in most situations and can also be used to take exposure readings, as well.

FILE FORMAT

RAW. RAW files offer the benefit of retaining the highest amount of image data from the original capture. If you are shooting on the go, however, and need faster burst rates, then RAW files will definitely slow you down. They will also fill up your storage cards or microdrives much quicker because of their larger file size. If you shoot RAW files, be sure to back them up as RAW files as well in order to preserve the most data.

Opening RAW files on your computer requires the use of special file-processing software that translates the image data and converts it to a useable format. Only a few years ago RAW file-processing software was limited to the camera manufacturer's software, which was often slow and difficult to use. Over time, the software and process has improved drastically. With the introduction of independent software, like Adobe Camera RAW and Phase One's Capture One DSLR, RAW file processing is not nearly as daunting. Additionally, new cameras with bigger buffers (and buffer upgrades for existing cameras) have improved the situation to the point where many pros shoot RAW files much of the time.

JPEG. Many cameras give you the option of creating image files at the JPEG Fine (or JPEG Highest Quality) settings. JPEG files are smaller than RAW files, so you can save more images per memory card or storage device. It also does not take as long to write the JPEG files to memory, allowing you to work much faster. The biggest drawback to JPEG files is that they employ a "lossy" compression format, meaning that they are subject to degradation by repeated opening and closing of the file. Most photographers who shoot in JPEG mode either save the

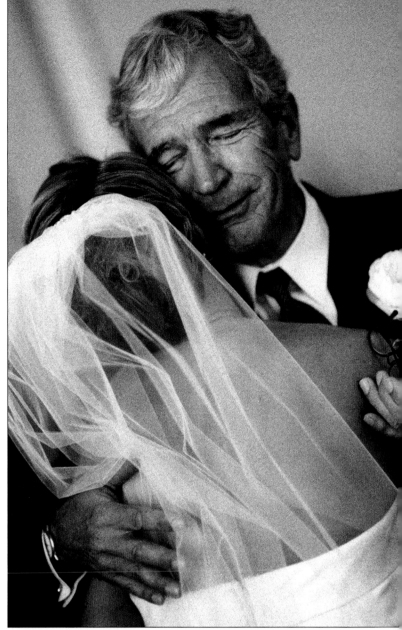

Wedding photojournalist Ann Hamilton shoots only with film and Nikon equipment. Her lenses of choice are Nikon's 16mm f/2.8 (fisheye), 50mm f/1.4, 85mm f/1.4, 105mm f/2.8, 17–35mm f/2.8, 28–70mm f/2.8, and 80–200mm f/2.8. She prefers the look and feel of film, but scans all of her wedding images using a Canon Canoscan FS4000US, which allows her to scan 35mm negatives at resolutions up to 4000dpi.

file as a JPEG copy each time they work on it or save it to the TIFF format (which uses "lossless" compression, meaning that it can be saved again and again without degradation).

COLOR SPACE

Many DSLRs allow you to shoot in either the Adobe RGB 1998 or the sRGB color space. There is consid-

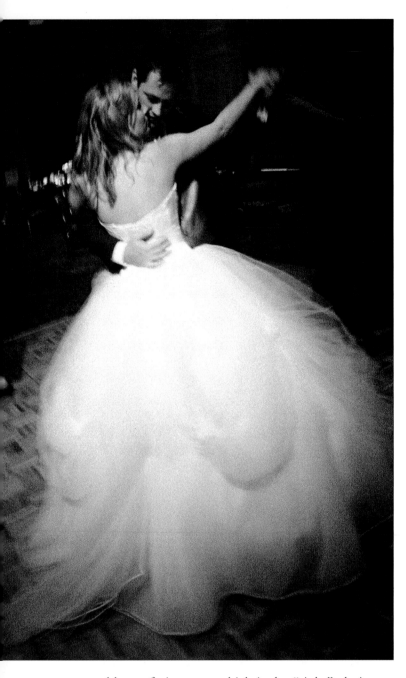

Becker created this image of the first dance with a Fuji FinePix S2 and 17mm lens wide open at $^1/_{15}$ second. There is some camera blur and lots of grain, which Becker enhanced and toned in Photoshop, creating a split-tone effect—partially warm tone, partially cool tone. The image is a masterpiece.

including cameras, monitors, and printers] other than sRGB, we recommend selecting the sRGB option for file creation. The native color space of many professional digital cameras is sRGB, and Fujifilm recommends the sRGB option as the working space for file manipulation when using Adobe Photoshop along with a fully calibrated monitor. End-users/photographers who alter the color space of the original file by using a space other than sRGB, without being fully ICC aware, are actually damaging the files that they submit to their labs.

Fuji's point of view seems to mirror that of professional digital labs, which use a standardized color space (sRGB) for their digital printers. Even though the Adobe 1998 RGB color space offers a wider gamut, professional photographers working in Adobe 1998 RGB will be somewhat disheartened when their files are reconfigured and output in the narrower color space. Thus the call for uniformity among professional photographers and labs.

There is also another school of thought. Many photographers who work in JPEG format use the Adobe 1998 RGB color space all the time, right up to the point that files are sent to a printer or out to the lab for printing. The reasoning is that since the color gamut is wider with Adobe 1998 RGB, more control is afforded. Wedding photographer Claude Jodoin works in Adobe 1998 RGB, preferring to get the maximum amount of color information in the original file, then editing the file using the same color space for maximum control of the image subtleties.

Is there ever a need for other color spaces? Yes. It depends on your particular workflow. For example, all the images you see in this book have been converted from their native sRGB or Adobe 1998 RGB color space to the CMYK color space for photomechanical printing. In general, I prefer images from photogra-

erable confusion over which is the "right" choice, as Adobe RGB 1998 is a wider gamut color space than sRGB. Photographers reason, "Why shouldn't I include the maximum range of color in the image at capture?" Others reason that sRGB is the color space of inexpensive point-and-shoot digital cameras and not suitable for professional applications. The answer is clearer after reading a recent trade publication from Fuji, which contains the following recommendation:

If the photographer's camera allows the "tagging" of ICC profiles [color profiles for devices

phers to be in the Adobe 1998 RGB color space, since they seem to convert more naturally to CMYK.

Ironically, if you go into Photoshop's color settings and select U.S. Pre-Press Defaults, Photoshop automatically makes Adobe RGB 1998 the default color space. By the way, out of the box, Photoshop's default color settings when installed are for Worldwide Web, which assumes the sRGB color space, and color management is turned off.

NOISE

Noise in an image occurs when stray electronic information affects the individual image sensors. It is made worse by heat and long exposures. Noise shows up more in dark areas, making evening and night photography problematic with digital capture. This is worth noting because it is one of the areas where digital capture is quite different from film capture.

SHARPENING AND CONTRAST

In your camera's presets or RAW file-processing software you will see a setting for image sharpening. You should choose "none" or "low" sharpening. The reason for this is that sharpening can eliminate data in an image and cause color shifts. Sharpening is best done after the other post processing effects are complete. Contrast should be set to the lowest possible setting. As Chris Becker notes, "It's easy to add contrast later, but more difficult to take it away."

METADATA

DSLRs give you the option of tagging your digital image files with data, which usually includes the date, time, and camera settings. After opening the image in Photoshop, you can then go to File>File Info to see a range of data including caption and identification information. If you then go to EXIF data in the Section pull-down menu, you will see the data that the camera automatically tags with the file. Depending on the camera model, various other information can also be written to the EXIF file, which can be useful for either the client or lab. You can also add your copyright symbol (©) and notice either from within Photoshop or from your camera's metadata setup files. Photoshop supports the information standard developed by the Newspaper Association of America (NAA) and the International Press Telecommunications Council (IPTC) to identify transmitted text and images. This standard includes entries for captions, keywords, categories, credits, and origins.

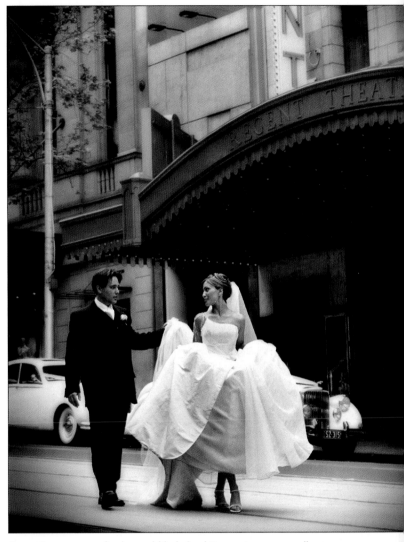

Intermittent areas of color and black & white create an unusually interesting wedding image. The viewer's eye darts between the monochrome and color areas of the print, then comes back to the bride and groom. Photograph by Jerry Ghionis.

Charles Maring
IMAGE GALLERY

Creating a world-class wedding album requires a perfect blend of photojournalism and portraiture, a reverence for print quality, and a design approach only possible through the use of digital technology. So says Charles Maring. "I began this realization approximately five years ago," he says, "and began a personal search for a concept that would not only emit the qualities that I believed strengthened our work, but that would create a greater demand for our work."

As a second-generation photographer, Charles grew up learning that behind every great photographer is an incredible printer. He has had a darkroom as long as he can remember and, like many photographers who have been in this field for a lifetime, that is where the magic happened for him as a child. Seeing a print transform from a blank piece of paper into a work of art in

mere seconds is a magic that still inspires him.

About five years ago, however, Charles and his wife Jennifer (also an award-winning photographer) made the leap to go digital for their portrait work. Everyone told him it was a mistake, but determination prevailed. Utilizing a Kodak 460 digital camera, he found that he could produce images that were far superior to what he was getting from any pro lab or in his own darkroom with film. New capabilities for self-promotion and self-expression came to life, and he was able to add an artist's interpretation. Soon, every image leaving the studio was digital—and print quality was still a key factor. "More than anything else," he says, "I watch clients leave our studio feeling like they have finally received the product and the service that other studios simply failed to offer."

There was only one problem. Workflow—they were doing all the work themselves. To add insult to injury, they were actually paying a higher price for digital than for analog prints. Charles began to research digital printing and, two years later, the studio purchased a Polielectronica Laser Lab, which is maintained in the U.S. by Colex Imaging. "I wanted the best of the best and felt that nothing compared for quality or speed. I can now have my order printed and packaged in less time than it took me to burn a CD," Charles says.

The raw speed of laser technology allowed them the luxury of employing staff and starting a new company run by the family called resolutionlab.com. Rlab works with a limited number of digital photographers needing output that has a higher standard of quality. Even though the Polielectronica was a $200,000.00 investment, Charles has noticed other well-known photographers making the same leap around the country.

Charles and Jennifer photograph approximately 25–30 weddings between them annually with a typical client spending well over $10,000. They also take on a limited amount of portrait work, and it is not unusual for Jennifer to exceed $2500 for a portrait sale. The studio also photographs a limited number of seniors each summer. Says Charles, "We do not put all of our eggs in one basket at our studio, gallery, or lab. One side of the business allows us to grow on the other, and vice versa. Most importantly, we enjoy all aspects of our business, and there is never a dull moment."

RIVERSIDE YACHT CLUB

LAT. 41° - 01.4' N LONG. 73° - 35.5' W

FOUNDED 1888 ★ MEMBERS ONLY

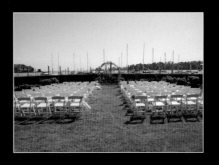

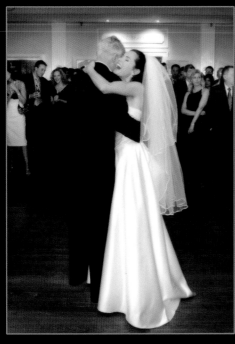

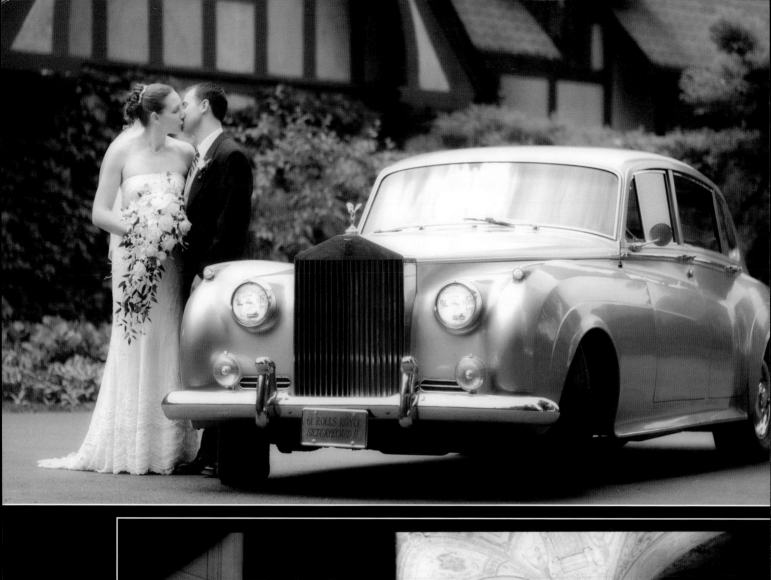

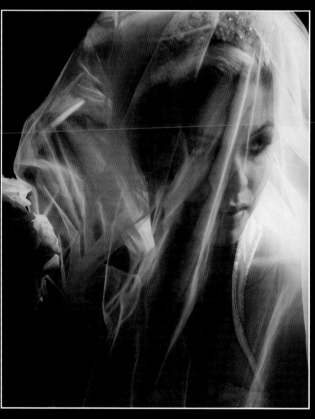

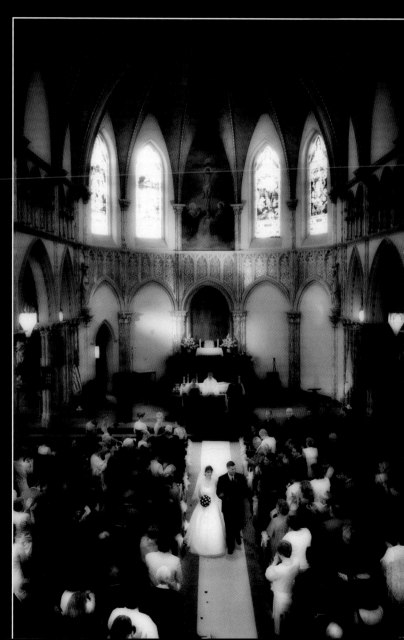

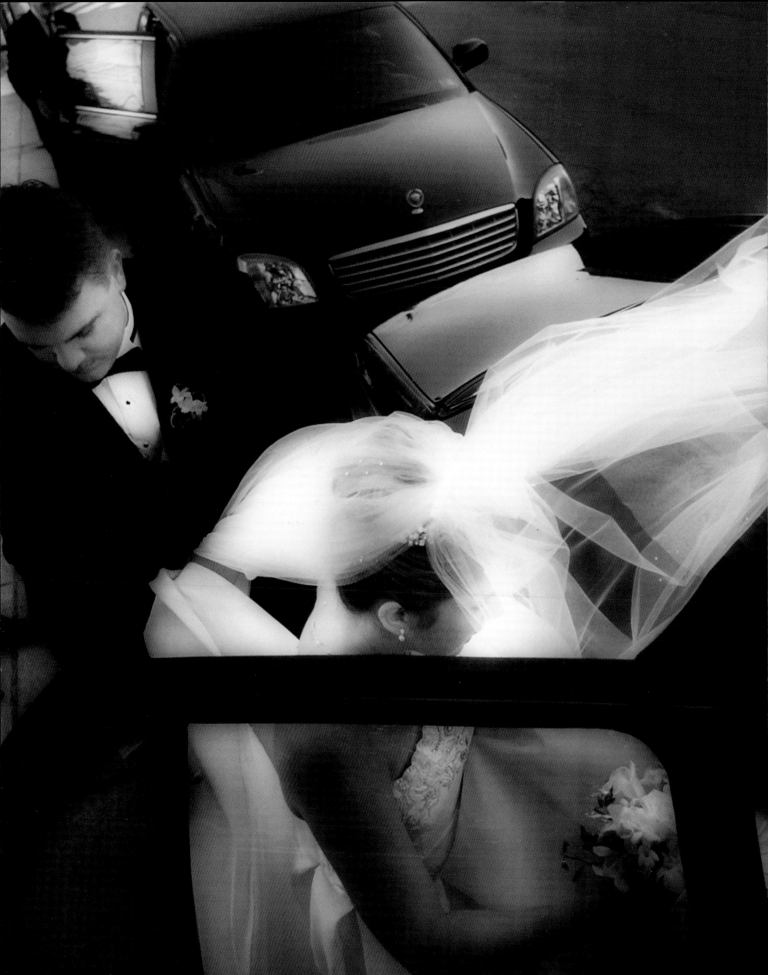

he wedding photographer's work-flow for a film-captured wedding is quite different from the digital photographer's workflow. The tasks include the same things—proofing, printing, retouching, and so forth—but the way the individual tasks are accom-plished is quite different and unique from photogra-pher to photographer.

JPEG WORKFLOW

Here is a basic workflow—courtesy of Michael Ayers, an award-winning photographer from Ohio. It as-

When Michael Ayers photographs groups, especially big formal groups, he will shoot several frames so that if somebody blinks or makes a sour expression, he can swap heads from a better image.

Michael Ayers labels each of the wedding folders, keying the name to the destination or a description of the folder's contents—FlipAlbum, EventPix, Engagement, and so on.

sumes that the files were captured as highest quality JPEGs (see page 75 for information on RAW file workflows). Michael's workflow is a good model because it includes printed proofs, a virtual proof album on CD, and sending JPEGs to a website for viewing and purchase by the client's guests and relatives.

Uploading. After the images have been captured, the memory cards or removable media are assembled and the process of uploading the JPEG files to your computer's hard drive can begin. FireWire or USB 2.0 card readers are recommended for this purpose, as their speed allows you to upload large numbers of image files quickly. Files should be uploaded to folders, which can be broken down according to chronology or function (pre-wedding, wedding, reception, and so forth). Some photographers consistently name these file folders 1000, 2000, 3000, etc. so that files named with those prefixes will be instantly recognizable as "wedding," "reception," and so forth.

File Backup. At this point, all image files should be backed up onto CD-Rs, as these are your source files—your originals. If you prefer, you can also use DVD-Rs, which have a higher capacity, so all of the folders can be copied onto one disk. You may also consider a portable hard drive as a suitable backup device, as well.

Edit and Adjust. At this stage, you can begin a basic edit. Any poorly exposed images or duplicates can be deleted. You can also rotate the images at this point for a proper orientation. As needed, make color or contrast change in Photoshop using Levels or Curves. Fix the obvious problems—like removing exit signs and cropping any odd compositions.

Image Manipulation. At this point you can begin to "play" with the images in Photoshop, using various plug-ins and actions to creatively alter the images. Some may be turned into monochrome or sepia-toned images, some may get selective coloring. The full gamut of creative effects is open to you. As Michael Ayers says, "The sky is the limit; the more creative, the better!" Refrain from doing extensive retouching at this point. Save this more labor-intensive work for the images that are ordered as prints or for the couple's album.

Rename. If you plan on manipulating the image further, save it as a TIFF file (remember, saving multiple times in the JPEG format will degrade the quality of the image). When all of the images are finished and in order, you may opt to rename them using a batch process in Photoshop. Michael's system calls for a three-digit serial number plus the extension, for example: 001.JPG, 002.JPG, 003.JPG.

Copy Again. Once the Photoshop work is complete, he makes another set of copies of the finished files in their folders. Michael prefers to make these copies to an external portable hard drive and recom-

mends disconnecting this hard drive from the computer and storing it unplugged in another location.

Proof Setup and Printing. Digital proofing and printing can be accomplished in a number of ways. For more on this, see chapter 5. Michael's studio likes to provide a 10 x 13-inch General Products album binder with proof pages printed "nine-up" (three rows of three), so each image is about 3 x 4 inches. He creates these using the Picture Index function in CompuPic Pro, which takes just a few minutes. There are other programs that will create similar proofs, including Photoshop (File>Automate>Contact Sheet II). Ayers will sometimes print these pages out on his Fujifilm PG 4500 printer in about an hour or send them to his lab, H & H Color Lab (Kansas City, MO), which also provides this service.

Michael also likes to use FlipAlbum Pro, a software program used to create attractive digital proof books on CD-ROM. To create a proof book, Michael first copies all of the finished images from his wedding folders to a folder called the FlipAlbum folder. Having a complete but separate folder for these images is a necessary step and prevents you from damaging or changing any originals from the wedding folder.

Using a batch process in Photosop (File>Automate>Batch), all of the images in this folder get resized to 1200 x 800 pixels. They are saved as a low-quality JPEGs (at the "3" quality setting—good enough for screen viewing) so that the FlipAlbum CDs will run at peak speed and require little disk space on a CD-R. (Michael will later upload these same photographs to the Eventpix.com website; see below.)

Special features of the FlipAlbum software include the ability to show panoramas, an index and table of contents, and security options like password protection, expiration date, and anti-copy/print functions. Michael generally produces several of these CD-Rs so that the couple and significant family members can have them to choose images and place orders.

Uploading to the Internet. There are a number of Internet companies that will display your wedding photos online and even handle online ordering and fulfillment for you. Michael uses Eventpix.com, because he says it is fast and secure for his clients to utilize and has resulted in many additional orders per wedding from people who would normally never have even viewed the images! He believes it is one of the services that has made his studio cutting-edge. It gives them an extra tool to recruit new brides to see their wedding work instantly! He usually uploads about 150 images per event and leaves them online

This is the interface for uploading wedding images at EventPix.com, the web-posting company Michael Ayers uses for his weddings and groups.

for about two months—selecting images that he knows the couple's family and friends will want to see.

Album Layout. The next step is designing the couple's album (for more on this, see chapter 7). Here again, using specialized software can make the job easier.

Michael likes to use Contact Sheet II in Photoshop, which allows you to print out tiny thumbnails of all of the couple's favorite images. He prints these little images on adhesive-backed paper and cuts them up into little stickers. Michael says of this method, "I've used many album-design software programs in the past and this manual option gives me greater flexibility with my creative pages."

With this done, he schedules an appointment for the couple to review the album choices, then they stick the thumbnails down onto squares, which represent the pages of the album. The couple usually has a lot of input as he shows them his ideas. The album will be built exactly as they have envisioned.

Retouching. When the couple has approved the album and all the orders are ready to be printed, go through each photograph one last time to check color and fix any problem (blemishes, glasses glare, stray hairs, shiny faces, etc.).

Print Orders. Once you've received all of the couple's orders, they need to be consolidated into a single print order. Using Fujifilm's Studiomaster Pro software can help with this. Studiomaster Pro lets you build a customer order that goes directly to your lab and provides all the tools you need to create a dazzling studio preview for your clients. It also allows cropping, resizing, and retouching to be done to your images before printing. Later, album orders are also arranged using this software. Michael raves about this workflow package, claiming it is quickly becoming the future of his studio's productivity, allowing a direct link between the camera, the computer, and the lab. Kodak offers a similar product called Pro Shots, which is currently in its sixth generation. It is functional and quite popular with both labs and photographers.

Album Orders. The type of album you decide to create (see chapter 7) will help determine the most efficient process for this stage of production. Michael

works with General Products, a Chicago-based album company, and faxes to them the album cover orders, as well as the order for mats, inserts, and panorama pages. Again, this is an area that differs greatly among photographers—Michael prefers mats and inserts; other photographers prefer digitally generated, hand-bound albums.

Print Sorting. When prints come back from the lab, you should check the quality and quantity. Note any missing or damaged prints so they can be sent out with the next order to the lab, then separate the prints into individual orders. At Michael's studio, the album prints are then put in order with the layout forms so they can be placed in mats, and all client orders are placed on the studio's work-in-progress shelves in the studio production room.

Folders and Mounting. Michael's studio uses folders to present 5 x 7-inch and smaller prints. Larger individual prints are mounted on premium-quality mount board. Michael believes that presentation is very important if you charge a premium for your work, so get the best photo mounts available for reasonable prices! Michael's album prints are placed in General Products mats and bonded permanently into the inserts, which are placed into the album cover.

Shipping. If your clients are local, set a special time to present the album to them for the first time and give them other related orders as well. Thanks to Internet ordering, wedding photographers now frequently need to fill orders for clients who live out of town. In this case, ship the finished products securely. Michael prefers to use specially lined boxes for this purpose.

Archiving. Finally, the entire set of folders should be archived to CD-R or DVD-R. It's a good idea to test this final disc (or discs) on another computer to make sure that each one operates perfectly. With this done, you are ready to delete this set of folders from the hard drive to make room for new wedding images. To maximize their life span, place your final CDs/DVDs in archival-quality containers (like jewel cases) and store them in a cool, dark, and safe place.

Ensuring the best possible exposure and the best possible white-balance setting when making the original photograph is by far the most significant step in

These are 32 x 50-inch and 32 x 32-inch files containing wedding images, including album pages and small prints. Note that photographer David Anthony Williams uses every square inch of space in order to have the highest-quality prints from the Durst Lamda 32-inch wide printer. David's workflow involves creating a number of these 32-inch wide files (up to 72 inches in length) to accommodate the entire print run for the wedding. The lab even trims the images for him. These images are printed for him by The Edge in Melbourne, Australia, and the price per 32-inch print is extremely reasonable. It does, however, take great organization and a completed order to have your work printed in this manner.

the workflow process, regardless of whether you're shooting JPEG or RAW files. To rely on the forgiving nature of the RAW file format is to set yourself up for countless hours of post-processing.

RAW WORKFLOW

The RAW-file workflow pattern is very similar, although it involves using RAW-file processing. After shooting RAW files at an event, the first step is to access the files and save them for editing, storage, and output. After displaying and verifying that all of the files exist on the memory card, save a version of all of your source files (in the RAW format). After making any needed modifications or adjustments, make another copy of all the files.

Some photographers, like Becker, prefer to download their images to a laptop in the field. Becker uses a G4 Powerbook and a Lexar FireWire card reader. Once the images are downloaded, he transfers them to an iPod (or other portable FireWire hard drive).

Get into the habit of creating multiple versions of your work in case you ever need to retrieve an earlier version of a file. Once backups are made, you can process your RAW files individually or use a batch process to apply certain characteristics to all the images—white balance, brightness, color-space tags, and more. Remember that your original capture data is retained in the source image file. Processing the images creates new, completely separate files. You can also save the new files in a variety of file formats, depending on what is most convenient for your image-editing workflow.

PROOFING OPTIONS

In addition to the proofing methods that have been mentioned previously, there are also two others worth

mentioning. Video proofing is inexpensive and simple, using a VCR, a slide show program (offered in many browser programs), and a television monitor. Digital projection involves an LCD projector and slide show treatment or DVD of the proofs, which can then be given to the clients to take home after their viewing session.

Both of the above methods involve scheduling an appointment for the bride and groom to view the proofs. Once the images have been viewed, many photographers send their clients away with a digital proof book. Using your digital files, you can print contact sheets of the images (that include the file name and number). These can be placed in a small but nice proof album for the couple to take with them.

PRINTING OPTIONS

Many photographers have the equipment and staff to print their own wedding images in-house. It gives them a level of control over the process that even the best lab cannot provide.

Other photographers have devised interesting ways to save money by employing the lab's wide-format printers. David Anthony Williams, for example, uses a lab called The Edge, in Melbourne, Australia. The Edge uses a Durst Lamda Digital Laser Imager, which produces full continuous tone images straight from Macintosh or PC files on photographic media. Williams prepares Photoshop files of finished album pages, panoramas, small prints, and proofs on a 32-inch wide file (the width of the lab's Lamda), using every square inch of space. The 32 x 32-, 32 x 50-, or 32 x 70-inch files are output at one time very inexpensively. The lab even trims all of the images for Williams, thus increasing his productivity and lowering his costs.

David follows the lab's guidelines and works in Adobe RGB (1998). The files may be TIFFs or JPEGs at 200–400dpi. The Edge will even provide a calibration kit on request to better coordinate your color space to that of the lab's.

REFORMAT YOUR CARDS

After you back up your source files, it's a good idea to erase all of the images from your CF cards and then reformat them. It simply isn't enough to delete the images, because extraneous data may remain on the card causing data interference. After reformatting, you're ready to use the CF card again.

Never format your cards prior to backing up your files to at least two sources. Some photographers shoot an entire job on a series of cards and take them back to the studio prior to performing any back up. Others refuse to fill an entire card at any time, instead they opt to download, back up, and reformat their cards during a shoot. This is a question of preference and security. Many photographers who shoot with a team train their assistants to perform these operations to guarantee the images are safe and in hand before anyone leaves the wedding.

David Beckstead
IMAGE GALLERY

tead is a documentary/fine-art tographer. He shoots with a S2 Pro and Nikon D1X bodies assortment of Nikkor lenses. m believer in the digital world, timate control over each and shot digitally" as a critical asset. h image as an art piece, he the details and subtleties of —a work habit he believes up on and appreciate. "Brides the 'photographer as an artist' says, "and they absolutely know ages of their special day will be wonderful, even months before ph them."

big fan of the camera-back dige calls it his "digital trainer," s him to see his progress hour ven though he may get a great image according to the LCD screen, however, he never treats the it as a finished work. "This is only the start," he says.

David is not fond of automation where individual image control is concerned. "Some of these routines are useful," he says, "yet when I hear of a photographer running 100 images through an action to bump the contrast, I cringe." Instead, he treats each image as unique and in so doing builds his reputation as a visual artist. He knows that brides seek him out because of that reputation and feels that automated processing, to a large degree, diminishes that level of creativity.

His workflow after the wedding includes backing up all of the images taken during the day multiple times, and making copies to an off-site location. Then he uses ACDSee software to cull up to 50 percent of the 2000+ images. He numbers the images, placing them in descriptive folders, then evaluates each and every one, 40 at a time, in Photoshop. Says David, "I judge each image with regard to cropping, color enhancement, or conversion to black & white (I shoot everything in color), contrast, and the many other elements it takes to push each image to new levels and into the realm of art." He then FTPs the final images to the lab and website posting company, and he's done.

David Beckstead believes that this attention to detail pays off in the long run. "Don't take my word for it," he says, "give this workflow a shot. The extra time spent will be rewarded in higher-paying jobs." See his website (www.davidbeckstead.com) for a detailed look at how David promotes his image as an artist in all of his marketing and sales efforts.

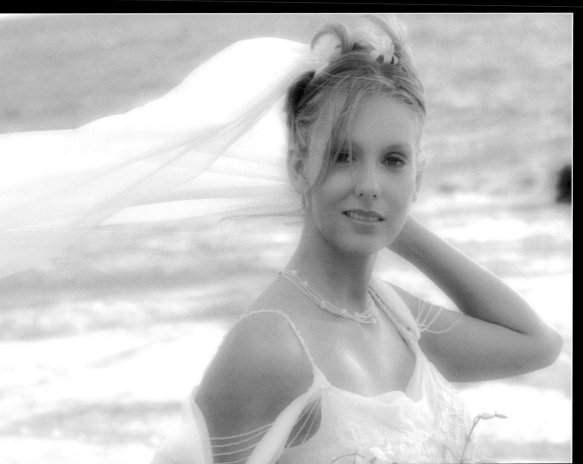

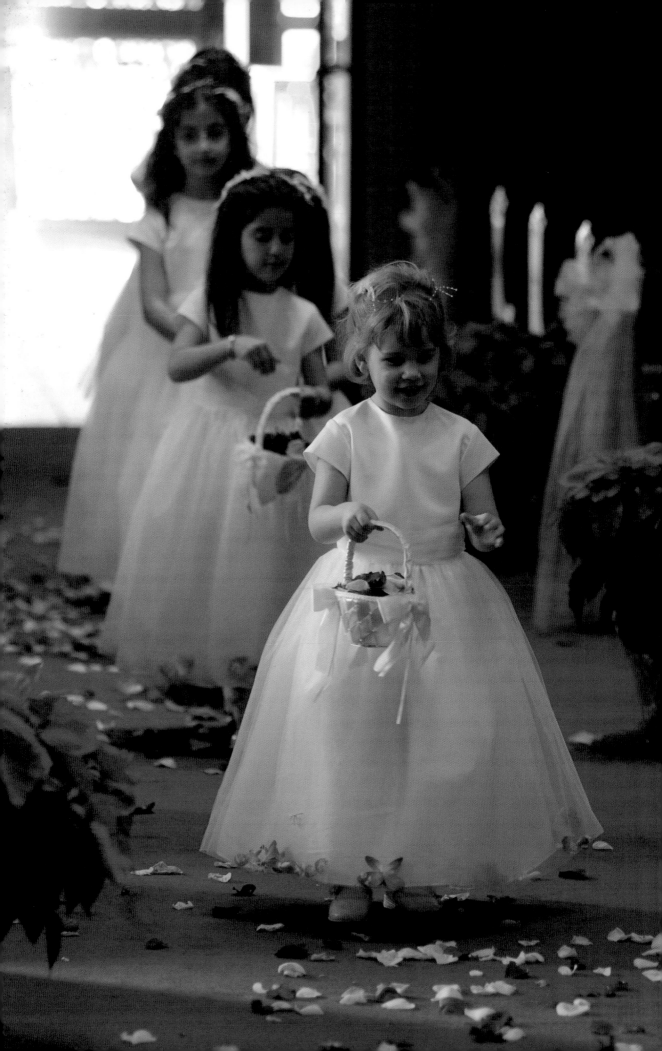

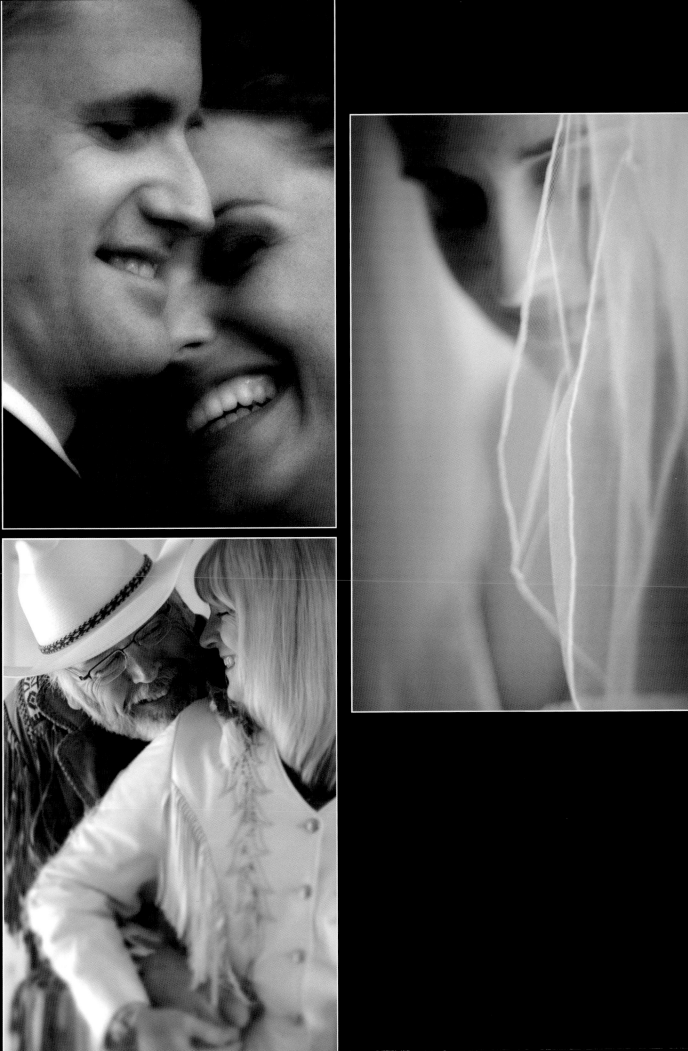

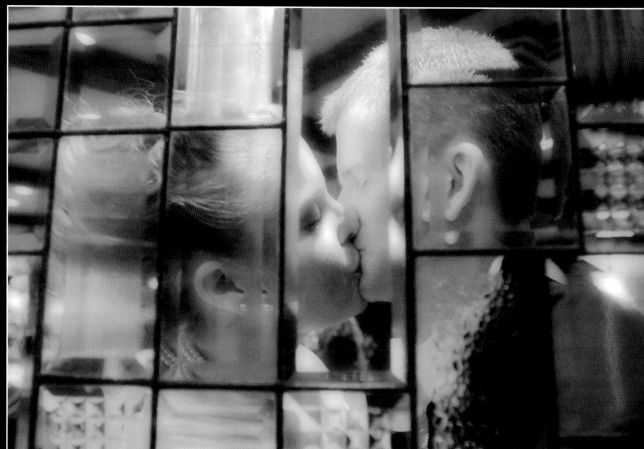

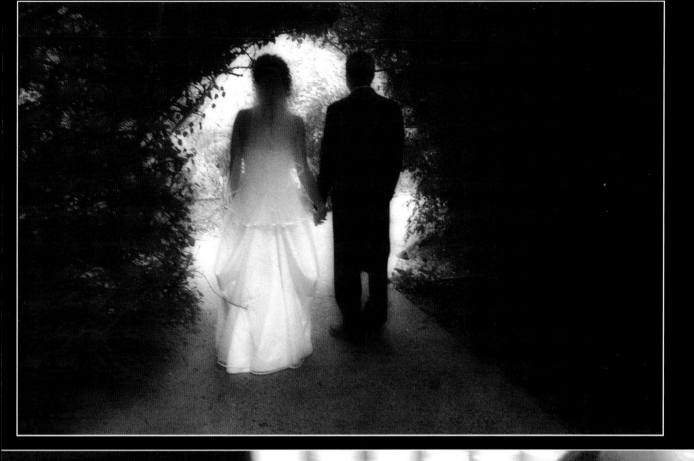

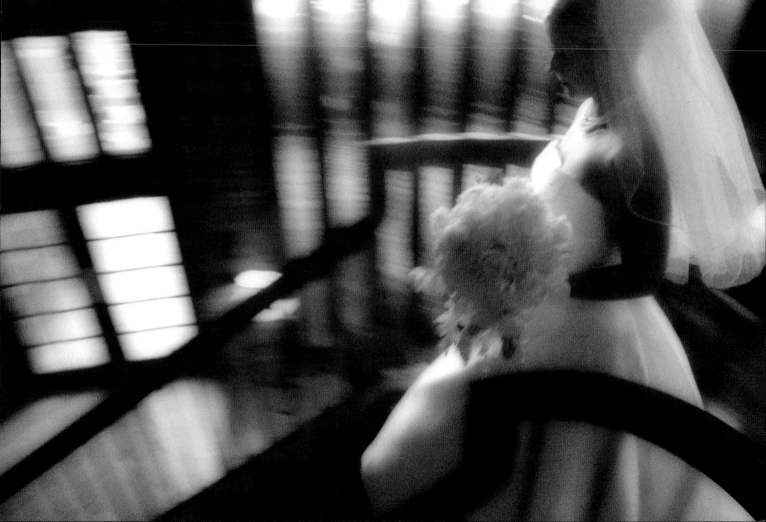

5. COLOR MANAGEMENT

Whether you are doing your own printing in-house or still working with a lab, you need an efficient and precise system of color management. This guarantees that what you see on your in-studio monitors will be matched as closely as possible in color and density to the final output.

Jeff Smith, an award-winning photographer, is like most photographers who have made the transition from film to digital. His workflow model with labs was well established and he was happy with years of beautiful printing from negatives. Jeff's studio simply cut the negatives, marked the order, and sent it off to the lab. The next time they saw the order, it was beautifully finished and ready to package and deliver. If the order wasn't right, the lab would redo it.

When his lab switched over to digital, however, he found he was not getting the quality he had gotten for the last 15 years. "Purple skin wasn't the look we were going for," he notes. With digital, Smith and company had to take over doing all the work and were charged the same price for digital output as printing from negatives. This means that the studio's lab bill was going to stay the same, but he would have to employ additional people to get all the files ready for the lab.

Smith investigated inkjet and dye-sublimation printers and found either the quality, cost, or time involved wasn't to his liking. He started to fantasize about the Fuji Frontier, the Rolls Royce of digital printers. He found, instead, an all-in-one digital printer/paper processor, the NetPrinter from Gretag. The Netprinter, like other digital printers from other manufacturers, is a self-contained printer/processor that prints on almost any photographic paper. Smith's Netprinter outputs up to 12 x 18-inch prints at 500dpi for an average cost of 35–45 cents per 8 x 10—and it can print up 200 prints per hour.

So what does this story have to do with color management? Well, what Smith found out was that even though the Netprinter came loaded with ICC profiles for the most popular papers, the studio wasn't getting consistent results. In the end, Smith ended up purchasing Eye One Calibration software to calibrate each monitor and write specific ICC profiles for the machine. This got the monitors close to the final output on paper, but still, the staff, as a group, had to learn to interpret the subtle differences between the colors and contrast of the monitors and how they reproduced on specific papers.

After a year, Jeff's staff is trained to interpret color—the customers are happy and so is he. According to Smith, "For our studio, this was a necessary step to make digital as profitable as shooting with film."

IT'S AN RGB WORLD NOW

RGB devices, including most digital cameras, scanners, and monitors, use red (R), green (G), and blue (B) light to reproduce color. A computer monitor, for example, creates color by emitting light through red, green, and blue glowing phosphors, which react with the thousands or millions of picture elements (pixels) located on the glass surface of the monitor to produce color.

A color management system performs two important functions—(1) it interprets the color values embedded in an image file and (2) it consistently maintains the appearance of those colors from one device to another, from input, to display, to output.

So why, even in a color-managed system, does the print output look different than the screen image? The answer lies not so much in color management as in the differences between media. Because monitors and printers have different color gamuts (the fixed range of color values that they can produce), the physical properties of these two different devices make it impossible to show exactly the same colors on your screen and on your paper. However, the use of effective color management allows you to align the output from all of your devices to simulate how the color values of your image will be reproduced in a print. As Jeff Smith found out, there is still a learning curve in determining and correcting these subtle differences.

MONITORS

Profiles. If you set up three identical monitors and had them display the exact same image, they would each display the image differently. Every monitor is different. This is where profiles come into play. Profiling, which uses a hardware calibration device and accompanying software, characterizes the monitor's output so that it displays a neutral (or at least predictable) range of colors.

A monitor profile is like a color correction filter. Going back to the example of the three monitors above, one monitor might be slightly green, one magenta, and one slightly darker than the other two. Once each monitor is calibrated and profiled, the resulting profile (stored in the computer) sends a correction to the computer's video card to compensate for the excess green, magenta, and brightness, respectively. With these profiles in place, all three monitors would present the same image identically.

Monitor profiling devices range from relatively inexpensive ($250–$500) to outlandishly expensive (several thousand dollars), but it is an investment you cannot avoid if you are going to get predictable results from your digital systems.

Gamma Settings. It is important to adjust your monitor's gamma correctly. "Gamma," when speaking of monitors, refers to brightness; it should not be confused with the film exposure/development system

Multiple G4s with dual monitors line the workroom at Jerry Ghionis's fabulous X-Sight studio in Australia. Each monitor is color corrected and profiled, part of the studio's overall color management system.

similar to Ansel Adams' zone system. Typically, monitors used with Macintosh systems have a default gamma setting of 1.8, while monitors used with PCs and Windows system have a default setting of 2.2.

Gamma refers to the monitor's brightness and contrast, and represents a known aim point. For example, if your video card sends your monitor a message that a certain pixel should have an intensity equal to x, the monitor will actually display a pixel with an intensity equal to x.

Both operating systems allow gamma to be adjusted, which can be important if your lab is using a different gamma than you. Also, both systems have built in self-correction software to optimize the accurate appearance of images.

Viewing Environment. To optimize your working area the room lighting should be adjusted to avoid any harsh direct lighting on the face of the monitor. This will allow more accurate adjustments to your images and will reduce eyestrain. Attempt to keep ambient light in the room as low as possible!

It is also recommended that you set your computer desktop to a neutral gray for viewing and optimizing images. Because you will most likely make adjustments to color and luminosity, it is important to provide a completely neutral, colorless backdrop to prevent colors in the periphery of the screen from influencing your judgment of the colors in the image.

CAMERAS

DSLRs are used in a wide variety of conditions. This is especially true of the wedding photographer, who may encounter as many as a dozen different combinations of lighting in a single afternoon, all with varying intensities. The wedding photographer is looking at a whole world of color.

Some camera manufacturers, like Canon, do not provide device profiles for their cameras. The main reason is that if all monitors are different, wouldn't the same hold true for digital cameras and how they capture color? Based on this, the thinking is that any single profile would be somewhat useless, since all cameras are slightly different. Besides, there are software controls built into the setup and processing modes for each DSLR that allow photographers suf-

ficient control to alter and correct the color of the captured image.

Custom camera profiles are beneficial if your camera consistently delivers off-color images under a variety of lighting conditions, or is capturing skin tones inaccurately or in situations where you need to render a specific color accurately (such as in the fashion and garment industry). Commercial photographers, for example, often use camera profiles to satisfy the color rendering needs of specific assignments.

Profiling Systems. One of the most inexpensive and effective camera profiling systems is ColorEyes. It is simple enough, albeit time-consuming. Basically, you photograph a Macbeth ColorChecker (a highly accurate and standardized color chart) and create a profile using ColorEyes software. The software looks at each patch and measures the color the camera saw. Next, the software calculates the difference between what the camera saw and what the reference file says the color is supposed to be. Third, the software builds the profile, which is actually a set of corrections to make the camera "see" more accurately.

While the wedding photographer would not necessarily profile the cameras used on location, a camera profile might prove beneficial in a studio setting where a specific set of strobes produces consistently off-color results. Although that profile would not be useful for any other situation than that studio and those lights, it is more convenient than other means of color correction.

Color Space. Most digital cameras are manufactured so that their color gamut is very close to a universal color space, such as sRGB or Adobe RGB 1998. These are "universal" color spaces, and any time a file is sent from one person to another (or from you to your lab), it should be in one of these color spaces. Most labs have a preferred color space, usually sRGB—but not always. Check with your lab to make sure your files are using the correct color space.

PRINTERS

Profiles. A custom profile for each inkjet paper you use gives the best color match between what you see on your calibrated monitor and the printed image. Output profiles produce the numeric values that the

printer requires to match the printed image to the one displayed on-screen. Custom profiles are essential to getting a color-managed print, and they also ensure that you are getting the full range of colors that your printer can produce.

Printer profiles are built by printing a set of known color patches. A spectrophotometer then reads the color patches so the software can interpret the difference between the original file and the printed patches. This information is stored in the form of an output profile, which is applied to images to ensure they are printed correctly.

Custom profiles, such as the Atkinson profiles, which are highly regarded, can be downloaded from the Epson website (www.epson.com) as well as a number of other sites. To use these you go to the website, then download and print out a color chart. Mail it back to the company and they will send you, via e-mail, a profile or set of profiles.

Another great source of custom profiles for a variety of papers and printers is Dry Creek Photo (www.drycreekphoto.com/custom/customprofiles.htm). This company offers a profile update package so that each time you change ink or ribbons (as in dye-sublimation printing) you can update the profile. Profiles are available for inkjets, dye-subs, and small event printers (Sony); Kodak 85- and 8600-series printers; Fuji Pictography printers; RA-4 printers (LightJet, Durst Lambda/Epsilon, Fuji Frontier, Noritsu QSS, Gretag Sienna, Kodak LED, Agfa D-Lab, etc.); color laserjets; and thermal printers. Most of the expensive commercial printers that labs use include rigorous self-calibration routines, which means that a single profile will last until major maintenance is done or until the machine settings are changed.

Soft Proofing. On a calibrated monitor, soft proofing allows you to see how an image file will appear when printed to a specific profiled output device. By referring to an output profile in an application like Photoshop, you can view out-of-gamut colors on your display prior to printing. Of course, accurate output profiles can save time and aggravation.

Careful control is needed to assure accurate color reproduction in digital images. Photograph by David Beckstead.

Yervant Zanazanian
IMAGE GALLERY

As a wedding photographer, Yervant Zanazanian has won every award worth winning in Australia—and now he's starting to win similar awards in the U.S. He is a superb photographer and designer, but part of the charm of his images is that he lets his subjects loose, freeing them from posing or worrying about having their pictures taken. He guides and directs, but in a pleasant, relaxed, and friendly manner.

Yervant is highly sought after for his unique style of wedding photography, but he is also well known for his unique magazine-style albums. Yervant pioneered the introduction of digital imaging and graphic design in professional wedding and portrait photography, winning the AIPP's initial major award for digital imaging in 1994.

Working with the Canon D1s and Canon L-series lenses, his favorite lens is the EF 16–35mm f/2.8L, with which he likes getting in close and "dancing" with the couple. He occasionally uses a small flash (either a Canon 550EX or Quantum Q flash), but existing light predominates in his photographs. Other lenses Yervant often uses include the EF 24–70mm f/2.8L USM; the EF 85mm f/1.2L USM; the EF 24mm f/1.4L USM; and the EF 70–200mm f/2.8L IS USM.

He likes the influence of tungsten lights in predominantly daylight situations and often mixes the two with excellent results. The ability of digital to change color temperatures is a feature Yervant uses to optimum effect.

An accepted part of the Australian wedding day is a delay of from an hour to half a day between the wedding ceremony and the reception. Getting couples together before the wedding for photography is very rare, so cafés, pubs, public streets, flower shops, restaurants, and public buildings become the backdrop for stunning pictures during those big lulls. Because of this, his assistant is never without a small portable video light, which Yervant uses as a key light in these often dark locations.

Yervant's workflow is relatively simple. Initial camera files are batch-processed, sorted, and organized before being sent to The Edge Lab in Melbourne via an FTP link for proofing. The lab proofs his images 12-up on an 11x14-inch sheet of paper. All images carry Yervant's logo, copyright notice, and image ID. Customers receive an attractive proof album of 500–700 images, from which they make their selections. Ordering and sales procedures are purposely kept relaxed and low-pressure, a technique that leads to referrals.

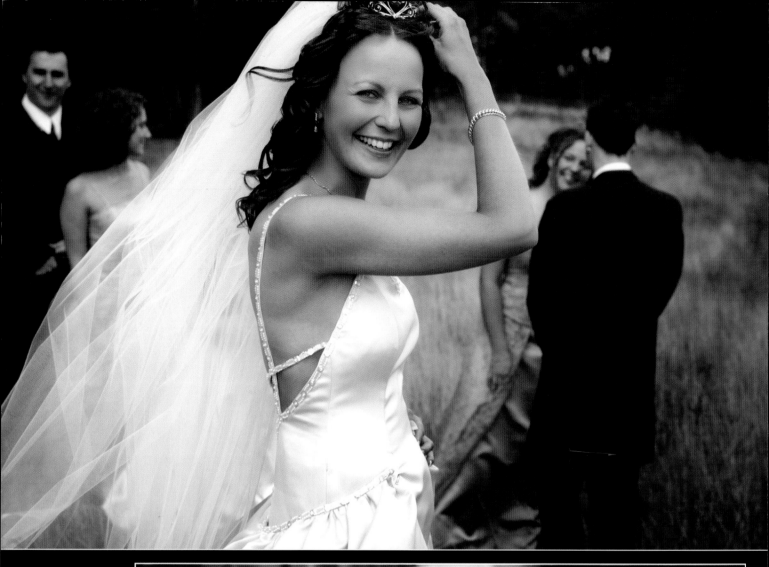

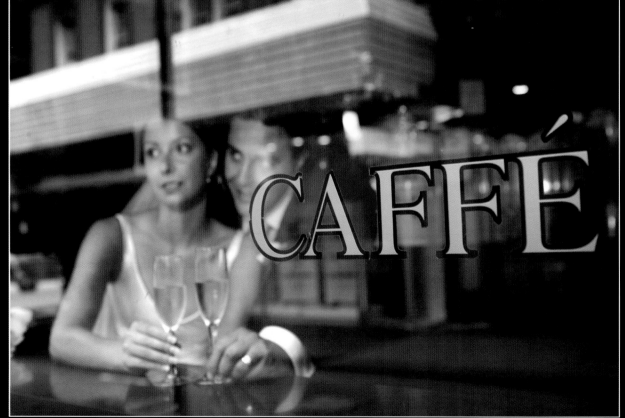

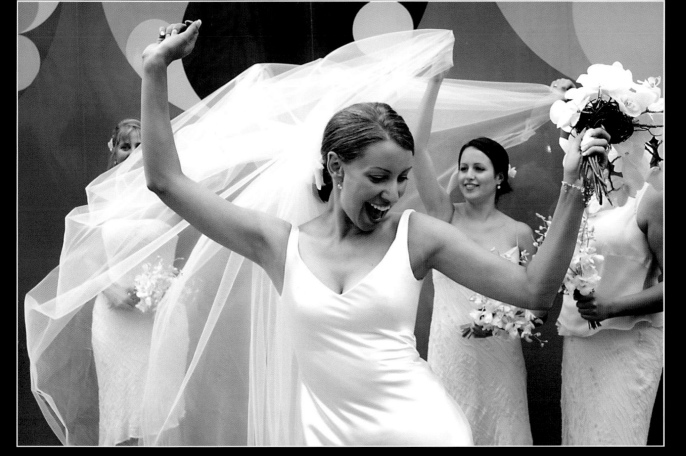
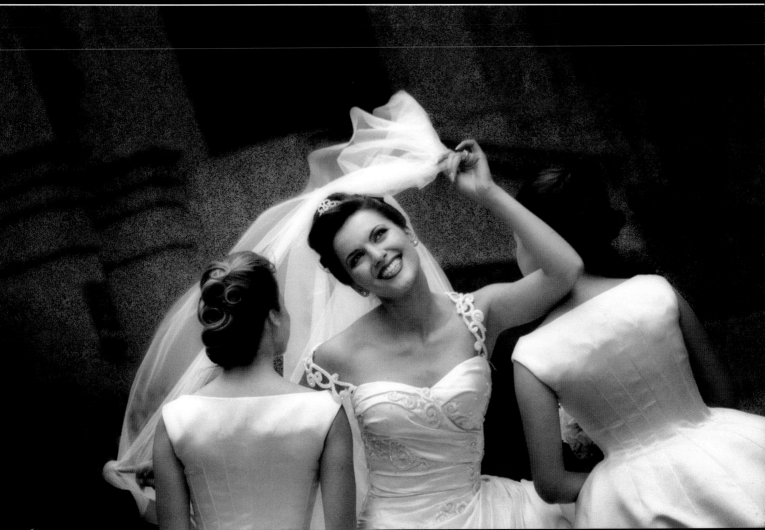

6. PHOTOSHOP TECHNIQUES

Adobe Photoshop is much more than a powerful software program for editing image files. It is a virtual digital darkroom, offering more creative flexibility than a conventional darkroom. Photoshop allows you to work on the image as a positive, allowing you to view the effect as you create it. Photoshop is also extremely open-ended—there are many different ways to do the same thing. As a result, certain techniques talked about here can be achieved by a number of different means.

Photoshop's flexibility also makes it open to a wide variety of unique techniques. If you sit down with six photographers and ask them how they do a fairly common correction, like selective diffusion, you just might get six different answers. Many practitioners pick up a technique in a book, then another at a workshop they've attended—and soon the technique has become a hybrid, with a slightly different method and result.

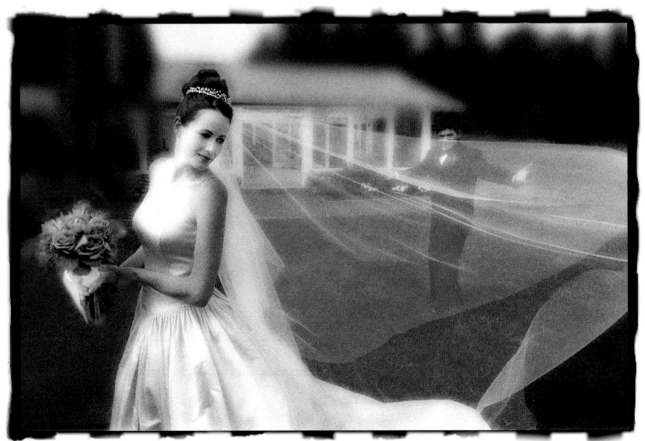

Scott Eklund created various levels of soft focus in this image to lower contrast in the subject lighting and create an unusual dreamscape background for this creative photo. Notice that the roof and frame of the building in the background are different grades of softness, which is only possible in Photoshop.

The following is a collection of Photoshop techniques useful to (but not exclusive to) digital wedding photographers.

BACKGROUND COPY LAYER

Many different creative effects involve using Photoshop's layers. When you open an image and go to the layers palette, you will see your background layer with a padlock icon next to it, meaning that this is your original image. Make a copy of the background layer by clicking and dragging the background layer onto the new-layer icon.

Immediately save the image in the PSD (Photoshop Document) or TIFF file format, which will allow you to preserve the layers, including the original background layer and background copy layer. Other file formats will require you to flatten the layers, which merges all the layers into one and obliterates your working layers. If for some reason you need to revert to the original image, you can simply delete all layers except your original background layer.

Once you've done this, you can continue working on the background copy. Because you are working on a duplicate of your original, it's easy to compare the "before" and "after" version of your image as you work and to revert back to the original if need be.

ERASER TOOL

Once you've made a copy of the background layer, the eraser tool allows you to selectively permit the underlying background layer to show through—good for creating selective effects.

For example, working on the background copy layer, you can apply the Gaussian blur filter (Filter>Blur>Gaussian Blur). This will blur the entire image. To restore the original sharpness to selected areas, you can then use the eraser tool to "erase" the blurred background copy layer and allow the sharp background layer to show through. You can set the eraser opacity and flow to 100 percent to reveal the hidden original background layer completely, or you can set the opacity to around 50 percent and bring back the sharpness gradually.

As you work, you'll probably want to enlarge the image to ensure that you erase accurately. You can

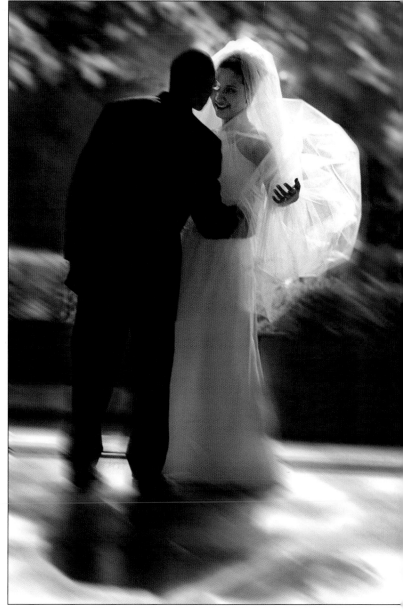

Scott Eklund created this image using the selective focus technique described here, but instead of Gaussian blur he used motion blur, which gives the diffusion some direction, not unlike camera movement. He then used the eraser tool to restore enough image information to make the image work.

also switch between different brushes, depending on the area you need to erase. Your selection of a soft- or hard-edged brush, and its size, will change the sharpness of the perimeter edge of the erased area. A good middle ground is a small- to medium-sized, soft-edged brush.

This technique is ideal for retouching the entire face and then bringing back select areas of the face that need to be sharp—the eyes and eyebrows, the

David Anthony Williams added selective soft focus to this image using the technique described above. Total elapsed time was about a minute. You can see the areas that David selected to be sharp—the eyes, the lips, the tip of the nose, the eyebrows, much of the hair, the buckle on the little boy's overalls, etc. There are certain areas of the face that need to be sharp or the image will look poorly focused.

nose, the lips and teeth, and so forth. It also works well with special effects filters, like nik ColorEfex's Monday Morning Sepia—a moody, soft focus, warm-tone filter. Simply perform the effect on the background copy layer, then bring back any of the original detail you want by using the eraser tool to allow the original background layer to show through.

SELECTIVE FOCUS

This ingenious trick was related to me by David Anthony Williams, who learned it from Yervant Zanazanian. It allows you to apply selective focus to various parts of the face without overall softening. Viewers are never even aware that the effect is in play.

Start with an RGB file. Duplicate the background layer three times so that you have four layers total. Activate the top layer, then apply the Gaussian blur filter (Filter>Blur>Gaussian Blur), setting the radius to 10. In the layers palette, change the mode of the blurred layer from normal to multiply. The image will look darker but more in focus. Go to Layer>Merge Down, reducing the image to three layers.

Use the midtone slider in the levels (Image>Adjustments>Levels) to lighten the image in accordance with your personal preference.

With the lasso tool, select the areas of the face that you want to appear sharp. Holding down the Shift key, select multiple areas. Feather the selected areas

(Select>Feather), entering a radius setting of 25 pixels (feathering distance is dependent on image size and resolution, so you may need to use a higher or lower setting depending on your file). Delete the selected areas by hitting the Delete key, then deactivate the selection (Command + D). In levels, lighten the top layer or darken the underlying layer (background copy 3) to blend with the overall image. Toggle between the layers to judge the effect.

Merge the top layer with the underling layer (Layer>Merge Down). You will now be left with two layers: your effects layer and your untouched layer. Adjust the levels one more time and, if required, flatten the image. (Note: If you are making a series of pictures with the same effect, do not flatten so you can match the density between the images.)

If you want to hasten this effect, duplicate the background layer, then blur the duplicate layer using the Gaussian blur filter (Filter>Blur>Gaussian Blur) at a radius of 10 pixels or less. Next, use the eraser tool with a soft-edged, medium-sized brush (at an opacity and flow of 100 percent) to reveal the hidden original background layer. Alternately, you can use the lasso tool to select the areas around the eyes and eyebrows, the hairline, the tip of the nose, the lips and teeth, the front edge of the ears, any jewelry that shows, and other surface details that should be sharp. Feather the selections and then hide them (Command + H) so that the line of "marching ants" that indicates the edge of the selection disappears. Then simply hit Delete, and the original background layer will show through. If you missed something, select the new area, feather the selection, and then delete.

BLEMISHES AND OTHER DISTRACTIONS

To remove small blemishes, dust spots, marks, or wrinkles, select the healing brush (if using Photoshop 6 or lower, select the clone tool). When this tool is selected, an options bar will appear at the top of the screen. Select the normal mode and choose "sampled" as the source setting. Next, select a soft-edged brush that is slightly larger than the area you are going to repair. Press Opt/Alt and click on a nearby area with the same tone and texture as the area you wish to fix. Then, click on the blemish and the sample will replace it. If it doesn't work, undo the operation (Command + Z), sample another area, and try again. The healing brush differs from the clone tool (also called the rubber stamp tool in older versions of Photoshop) in that the healing brush automatically blends the sampled tonality with the area surrounding the blemish or mark.

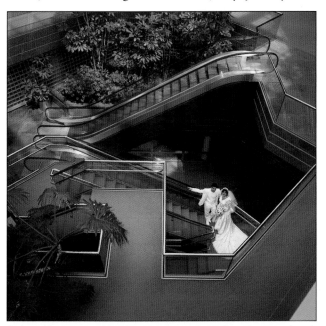

Robert Kunesh is a digital artist who is also a fine photographer. In the original image (left), he has created a geometric composition that relies on the brass handrails for shape. In the enhanced image (right), he twirled the image in Photoshop to produce a spherical effect, leaving the bride and groom undistorted. The final image is an award winner.

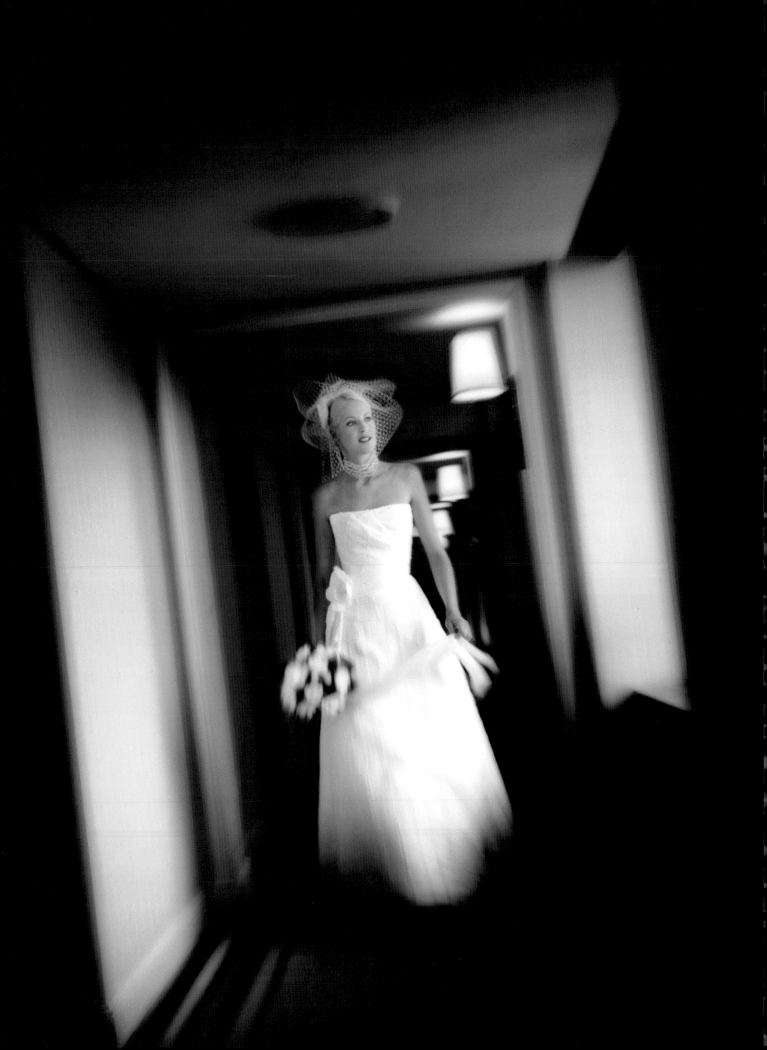

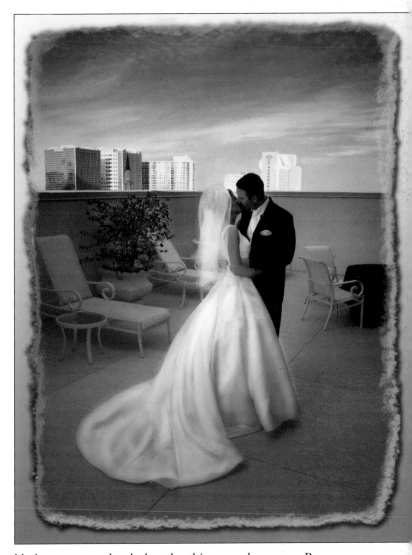

To remove larger unwanted elements, try this technique from Deborah Ferro. Start by opening an image and duplicating the background layer. Zoom in on the area that contains the object you want to remove. With the lasso tool set to a feather radius of 2 pixels, select the area you want to remove. Once selected, use the clone tool (set to 100 percent opacity) to sample an adjacent area and fill the selection. Feathering helps the areas blend better. When you're happy with the tone and texture of the area, deselect it (Command + D). Then you can use the healing brush or smudge tool to smooth out any uneven areas.

SHININESS AND WRINKLES

Shininess and wrinkles are lumped together because fixing them is easily done using the same tool and techniques.

To reduce the appearance of wrinkles and shiny areas, select the clone tool and set its opacity to 25 percent. The mode should be set to normal and the brush should be soft-edged. As you would when using the healing brush, sample an unblemished area by hitting Opt/Alt and clicking once on the area you want to sample. As you use the tool, keep an eye on the crosshair that appears to show you the sampled area you are about to apply with your next click of the tool. If this area begins to move into a zone that is not the right color or texture, hit Opt/Alt and resample the desired area.

The clone tool is a very forgiving tool that can be applied numerous times in succession to restore a relatively large area. As you work, you will find that the more you apply the cloned area the lighter the wrinkle becomes or the darker the shiny area becomes. Be sure to zoom out and check to make sure you haven't overdone it. This is one reason why it is always safer to work on a copy of the background layer instead of on the background layer itself.

When reducing shine, it is important not to remove the highlight entirely; instead, just subdue it. The same goes for most wrinkles. For a natural look, they should be significantly subdued, but not completely eliminated.

TEETH AND EYES

By quickly cleaning up imperfections in the eyes and teeth, you can put real snap back into the image. To do this, use the dodge tool at an exposure setting of 25 percent. Since the whites of the eyes and teeth are only in the highlight range, set the range to highlights in the options bar.

For the eyes, use a small soft-edged brush and work the whites—but be careful not to overdo it. For teeth, select a brush that is the size of the largest teeth and make one pass. Voilà! That should do it.

For really yellow teeth, first make a selection using the lasso tool. It doesn't have to be extremely precise. Next, go to Image>Adjustments>Selective Color. Select "neutrals" and reduce the yellow. Make sure that the method setting at the bottom of the dialog box is set to absolute, which gives a more definitive result in smaller increments. Remove yellow in small increments (one or two points at a time) and gauge the preview. You will instantly see the teeth whiten. Surrounding areas of pink lips and skin tone will be unaffected because they are a different color.

GLARE ON GLASSES

Glare on glasses is easily remedied. Enlarge the eyeglasses, one lens at a time. With the clone tool, select a small, soft brush and set its opacity to about 50 percent. The reduced opacity will keep the glass looking like glass. Sample an adjacent area (Option/Alt + click) and cover over the highlight. Deborah Ferro, a Photoshop expert, suggests using irregularly shaped brushes of different sizes to cover tricky highlights.

COLOR CORRECTION

Even if the final destination for your image is the CMYK color space (for offset printing, for example), all of your retouching and color corrections are better handled in RGB. CMYK color has a limited gamut (range of colors) as compared to RGB. The more you work on an image in CMYK, the more anomalies will occur. If you invest a lot of time and effort retouching and color correcting, it is also wise to save a finished RGB version for future use before making the final conversion to CMYK.

Many people prefer to use curves to color correct an image, but I prefer the selective color tool. It is among the most powerful tools in Photoshop. To open this tool, go to Image>Adjustments>Selective Color. In the selective color dialog box, you'll see slider controls for cyan, magenta, yellow, and black. At the bottom of the box, make sure that the method is set to absolute, which gives a more definitive result in smaller increments. At the top of the box, choose the color you want to change by selecting it from the pull-down menu. You can choose to alter the reds, yellows, greens, cyans, blues, magentas, whites, "neutrals," or blacks. Once you've selected the color to change, simply adjust the sliders to modify the selected color in whatever way you like.

The changes you make to the sliders in the dialog box will affect only that color. Note, however, that the changed values will affect every area of that color. Therefore, if you select "blue" to change the color of

Tony Florez created this lovely sepia-toned image.

In this beautiful image, Joe Photo photographed the bouquets atop a vintage roadster. In Photoshop, he desaturated the background copy layer and then restored the color of the flowers by erasing them. He also added a very soft-edged vignette (an effect discussed later in this chapter).

the sky, it will also change the blue in the subject's eyes and her blue sweater.

When using the selective color command, most skin tones fall into the range that is considered neutral, so you can color correct the skin tones without affecting the white dress or the brightly colored bridesmaid's gowns, for instance. Skin tones are comprised of varying amounts of magenta and yellow, so these are the sliders that normally need to be adjusted. In outdoor images, however, you will sometimes also pick up excess cyan in the skin tones; this can be eliminated by using the cyan slider. For teeth that are yellowed, select "yellows" and remove yellow with the sliders to brighten teeth.

Wedding dresses will often reflect a nearby color, particularly if the material has a satiny sheen. Outdoors, the dress might go green or blue, depending on whether shade or grass is being reflected into the dress. In this case, you would select "whites" from the color menu. Then, if the dress is blue, you'd

remove a little cyan and judge the results. If the dress has gone green, add a little magenta and perhaps remove a slight amount of yellow.

In selective color, the black slider adds density to the image and is much like the levels control in Photoshop. Be sure to adjust only the blacks using the black slider, otherwise it will have the effect of fogging the image. When converting images from RGB to CMYK, the black slider is very useful for adding the punch that is missing after the conversion.

If you've spotted a problem in your image but aren't quite sure of the color shift, there is a useful product available from Kodak for making color prints from negatives or slides. It is called the Kodak Color Print Viewing Filter Kit, and is comprised of six viewing cards—cyan, magenta, yellow, red, green, and blue. With a medium-gray neutral background on you monitor desktop, inspect the image on the monitor using the card that is the complementary color of the suspected color shift. For example, if the shift

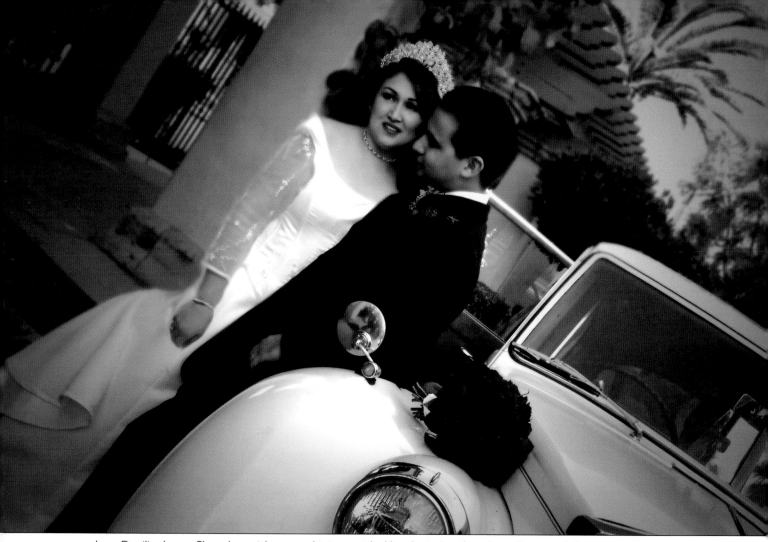

Jerry D utilized many Photoshop tricks to get this image right. He selectively softened it and vignetted the image with a diffused colored vignette—and then the magic started. The bride asked him to make her slimmer, which he did by moving her arm closer to her body to mask the line of her torso.

looks blue, use the yellow card to view the image. If the color shift is green, choose the magenta card, and so on. With one eye closed, flick the appropriate card quickly in and out of your field of view, examining the midtones as you do so. Avoid looking at the image highlights, as you will learn nothing from this. If the yellow card neutralizes the color shift in the midtones and shadows, then you are on the right track. There are three densities on each card, so try each one before ruling out a specific color correction. Once you've identified the problem, use the appropriate selection and sliders in the selective-color dialog box to neutralize the color shift.

DIGITAL TONING

With your image in RGB color mode, create a copy of the background layer. Working on that layer, go to Image>Adjustments>Desaturate to create a mono-

tone image. Use the levels or curves to adjust the contrast at this point, if so desired. Next, go to selective color (Image>Adjustments>Selective Color) and choose "neutrals" from the color menu. Then adjust the magenta and yellow sliders to create a sepia look. Using more magenta than yellow will give you a truer sepia tone. Adding more yellow than magenta will give a brown or selenium image tone. The entire range of warm toners is available using these two controls. If you want a cool-toned image, you can add cyan or reduce yellow (or both). Again, a full range of cool tones is available in almost infinite variety.

MIXING COLOR AND BLACK & WHITE

A popular effect is to add bits of color to a monochrome image. This technique is done by duplicating the background layer of a color image, then desaturating it (Image>Adjustments>Desaturate). Working

on the duplicate layer, adjust brightness and contrast to your liking, then select the eraser tool. Choose a medium-sized soft brush and set the opacity of the eraser to 100 percent. Then, start to erase the areas you want to be in color (allowing the underlying color layer to show through the black & white desaturated layer in the erased areas).

VIGNETTES

Vignettes can help focus the viewer's attention on the subject's face. Many photographers vignette every image in printing, darkening each corner to emphasize the center of interest in the image. Even in high-key portraits, vignetting is a good way to add drama and heightened interest in the main subject.

This particular Photoshop vignetting technique comes from photographer and digital artist Deborah Lynn Ferro. To begin, duplicate the background layer. In the layers palette, create a new layer set to the normal mode.

Then, select a color for the vignette by clicking on the foreground color in the main toolbar to bring up the color picker. You can choose any color or sample a color from within the photograph to guarantee a good color match (this is done using the eyedropper tool—click once and the sampled color becomes the foreground color).

Next, use the elliptical marquee tool or the lasso tool to select an area around the subject(s). Inverse the selection (Select>Inverse) and feather it (Select>Feather)—the larger the number, the softer the edge of your vignette will be. Try feathering to a radius of 75 to 100 pixels to keep the edge of the vignette really soft.

Working on the new layer, fill the feathered selection (Edit>Fill) with the foreground color using a low opacity percentage (like 10 percent). Be sure to select the "preserve transparency" option at the bottom of the fill dialog box.

You can also combine the vignette with various other filters. For example, if you want to remove unwanted details, add a motion blur (Filter>Blur> Motion Blur) to the feathered background. The effect will wash away any unwanted image details and create a beautifully stylized, yet subtle effect.

STRAIGHTENING VERTICALS

One of the most amazing features in Photoshop is the transform tool (Edit>Transform). Using it, you can effectively correct architectural verticals in an image. Here's how it's done. Open your image and use the navigator palette to make your image smaller than the surrounding canvas (move the slider in the navigator palette to the left). Turn your rulers on (View> Rulers). With your cursor, click on the horizontal or vertical ruler and drag a rule into position, placing it on the edge of one of the crooked lines so you will be able to gauge when the line has been straightened. Select the entire image (Command + A) and go to the transform function (Edit>Transform>Skew). Handles will appear on all four corners of the image. Drag on the corner handles to push or pull each edge of the image, correcting the vertical or horizontal lines within the image. When the lines are straight, press Return or Enter and the effect will be processed. Be sure not to skew the details out of perspective.

CHANGING IMAGE RESOLUTION

Logic dictates that this technique, which is courtesy of David Anthony Williams, shouldn't work at all— but it does. It doesn't work with every file unfortunately, but files that are sharp and well exposed to begin with will enlarge with ease.

Start with an RGB image and convert it to the Lab Color mode. Open the Channels palette and activate the lightness channel. Go to Image>Image Size and increase the size, making sure that you are resampling the image and constraining proportions. For large increases, use two steps. For instance, to go from an 8 x 10-inch image to a 30 x 40-inch image, first increase the size to 16 x 20 inches, and then adjust the image size again to 30 x 40 inches.

Next, still working on the lightness channel only, open the unsharp mask dialog box (Filter>Sharpen> Unsharp Mask) and use the following settings: amount—80 percent; radius—1.2 pixels; threshold— 0 levels.

Return to the channels palette and choose the Lab channel, which will restore the color to the image. Return the image to RGB mode for printing or other operations.

The theory behind why this works is that you are readjusting the size of the image by adjusting the architecture of the image, not the color. This technique really works. However, if the quality of the original is not very good or if you are using a very small file that is already suffering from jaggies or other artifacts, the amount of resizing you will be able to do will be minimal.

SHARPENING

As most Photoshop experts will tell you, sharpening is the final step in working on an image, and one of the most common flaws in an image is over-sharpen-ing. Photoshop's sharpen filters are designed to focus blurry or softened images by increasing the contrast of adjacent pixels. This makes it easy to over-sharpen an image and compress detail out of an area or the entire image.

The most flexible of Photoshop's sharpening tools is the unsharp mask filter. In the unsharp mask dialog box, you can adjust three settings. The amount setting dictates how much the contrast should be increased on the edge pixels. The radius setting controls the number of pixels surrounding the edge pixels that will be affected in the sharpening (a lower value sharpens only the edge pixels, whereas a higher

James Williams, an expert wedding and senior photographer, feels that a great portrait of the groom really sets an album apart. Here, Jim used side lighting and a carefully placed reflector to create this effective portrait. The splash of color supplied by the geraniums hanging in the background makes this shot a real winner.

value sharpens a wider band of pixels). The threshold setting determines how different the sharpened pixels must be from the surrounding area before they are considered edge pixels and sharpened by the filter. The default threshold value of zero sharpens all the pixels in the image.

This filter needs to be used carefully. If you sharpen the image in RGB mode, you are sharpening all three layers simultaneously. This can lead to color shifts and degradation in quality. A better method is to convert the image to the Lab Color mode (Image> Mode>Lab Color). In the channels palette, click on the lightness channel to deselect the A and B channels (the image will look black & white). Use the unsharp mask filter to sharpen only that channel, then restore the A and B channels by clicking on the composite Lab channel at the top of the channels menu. Go to Image>Mode to convert the image back to the desired mode, and you will be amazed at the results—particularly if you have been sharpening the entire image in past efforts.

Another way to effectively use the unsharp mask filter is to apply it to just one channel in an RGB image. To see the difference this makes, duplicate your image (Image>Duplicate) and place the two identical windows side by side on your screen. On one image, apply the unsharp mask without selecting a channel. In the unsharp mask dialog box, select the following settings: amount—80 percent; radius—1.2 pixels; threshold—0 levels. On the second image, go to the channels palette and look at each channel individually. Select the channel with the most midtones (usually the green channel, but not always) and apply the unsharp mask filter using the same settings. Then, turn the other two channels back on. Enlarge a key area, like the face, of both images to exactly the same magnification—say 200 percent. At this level of sharpening, you will probably see artifacts in the image in which all three layers were sharpened simultaneously. In the image where only the green channel was sharpened, you will see a much finer rendition.

ACTIONS

Photoshop actions are a series of commands that you record as you perform them and then play back to apply the same functions on another image or set of images—with a click of your mouse. Actions are accessed via the actions palette (Window>Actions).

To create a new action, select "new action" from the pull-down menu at the top right of the actions palette. You will be asked to name it, and then to start recording. Once recording, everything you do to the image will be recorded as part of the action (there are a few exceptions, such as individual brush strokes, that cannot be recorded). When done, simply stop recording by hitting the stop button (the black square) at the bottom of the actions palette. Then, whenever you want to perform that action, go to the actions palette, select the desired action, and hit the play button at the bottom of the palette (the black triangle). The action will then run automatically on the open image.

Photoshop also comes with a variety of preloaded actions. You can use these actions as is or customize them to meet your needs. You can also purchase actions from reliable sources on the internet to utilize the experience of some of the best in the business. For example, Fred Miranda (www.fredmiranda.com) has a site that contains a wide variety of excellent actions for sale at a reasonable price.

WORKIN' IT
WITH
Jerry D

Jerry D is an award-winning wedding photographer from Upland, California. For Jerry, the captured digital image is never the final image. I was lucky enough to sit in on a typical Photoshop session with him while he "worked" an image to his liking. All in all, Jerry spent about 20 minutes on the image and much of that time was spent explaining things to me and repeatedly "Saving As" so we could show the sequence of steps.

LEFT—Here is the original image made in late afternoon outside a public building in Riverside, California. The image was made with a Canon 1Ds and wide-angle zoom (at the 37mm setting). The ISO was 640 and the exposure was $1/30$ second at f/4.6. The composition and pose are good, as is the light. **RIGHT**—Jerry cropped the image, taking out the distracting space to the right of the second column and cropping into the edge of the arch to the left. Now the subjects and the architecture balance and the couple is prominent.

LEFT—In Photoshop, Jerry went to the Brightness/Contrast controls and boosted contrast to add a little "punch," and lowered the brightness slightly to add mood. Enlarging the image of the couple reveals that the image is noisy and that it could stand some serious sharpening. Jerry prefers to do the sharpening at this stage of the image manipulation rather than waiting until the end, as is customary. **RIGHT**—Jerry used two custom actions from Fred Miranda (www.fredmiranda.com) called ISOx Pro and Intellisharpen. The former reduces undesirable noise naturally and without trace, keeping the detail intact. Intellisharpen is ideal for images captured at high ISOs. It sharpens the image without sharpening noise and artifacts, providing excellent results.

 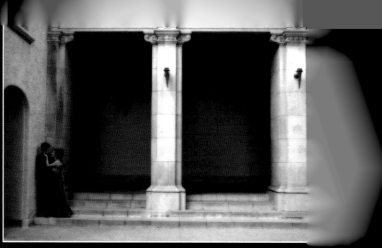

LEFT—The next phase of the manipulation involves using nik Color Efex plug-ins. In this case, Monday Morning Sepia was used to bring out the texture in the stucco and enhance the mood. First, Jerry duplicated the image. Others might create a background copy layer, but Jerry prefers to duplicate the image so he can look at both files simultaneously. Jerry adjusted the color of the image in Color Balance Adjust, adding red and a slight amount of green until he was happy with the color and depth of the sepia tone. **RIGHT**—Using the move tool, Jerry dragged the duplicate image on top of the original image, being careful to align it exactly. With the eraser tool set at 74-percent opacity and 68-percent flow, he began to erase the image of the couple, using a fairly large, soft-edged brush. Using lower opacity lets you bring up the underlying original image more gradually, but Jerry may have to work 100 images at a setting, so he has learned to work quickly. He uses two different techniques to reveal the image: fast clicks of the mouse over a wide area or a slow drag of the tool, especially along the edges of the couple. You can see that the image now is a combination of two images.

LEFT—Now comes the fun part. Jerry burned in parts of the image to reveal the texture of the stucco as well as to reveal the beautiful yellow color in the columns. Using the burn tool, he selected a large brush and an exposure of 25 percent, then burned in the columns and steps—being careful not to make it look too even. A dappled uneven look works best. He burned a little more at the top of the columns to recapture intricate detail. Watching Jerry burn the area is totally different than the darkroom version of burning in. He used a sponging motion with the mouse and worked fairly slowly, undoing any area that got overdone. The most interesting thing he did here was to burn in the shadows, which are almost black already. He burned in around the frame of the black rectangles, leaving the center untouched. Burning in the shadows, he says, creates mystery. **RIGHT**—Jerry liked the image at this point but was not satisfied with the lights on the

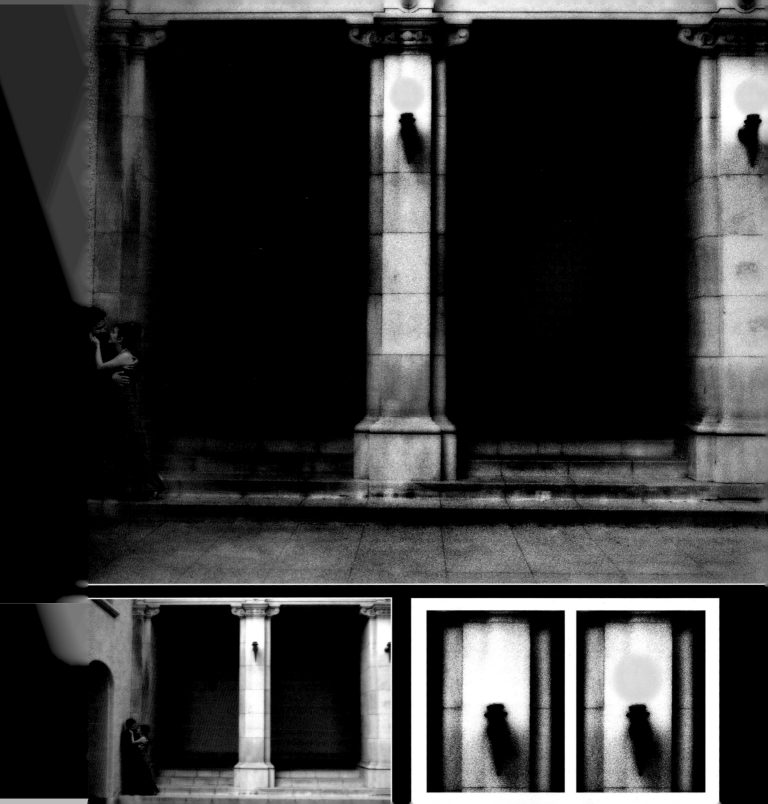

Digital technology has made it possible for photographers to create wedding albums with greater ease—and greater variety—than ever before. Increasingly, photographers are also functioning as designers, applying their visual skills to the creation of dynamic page layouts.

TYPES OF ALBUMS

Traditional. The traditional album is one that features mats that accommodate different sizes of prints. These then slip into a fine-quality insert, which is post-mounted in a beautiful leather album. For years this was the hallmark of wedding albums. Many album companies offer a great variety of different album page configurations for placing horizontal or vertical images in tandem on a page, or combining any number of smaller images.

Library Binding. Another form of album uses conventional photographic prints made to the actual page size. These prints are then mounted, trimmed, and bound in an elegant leather album that is actually a custom-made book. If you want to create album pages with multiple images, your lab must prepare these composite prints before submitting them to the album company for binding.

Magazine Style. A different kind of album is the bound album, in which all the images are permanently mounted to each page and the book is bound professionally by a bookbinder. The images on such pages can run "bleed," meaning that the image is printed edge to edge on the page. These are elegant and very popular with modern brides. Since the pho-

tos are mounted on each page, the individual pages can support any type of layout from "double-truck" (two bleed pages) layouts to a combination of any number of smaller images.

The magazine-style album features graphic page layouts with a sense of design and style. Images are not necessarily treated as individual entities but are often grouped with like images, bounded by theme rather than in chronological order. This affords the photographer the luxury of using many more pictures in varying sizes throughout the album. Collages and other multimedia techniques are common in the magazine-style album, and you will often see text used sparingly throughout. Because there are no boundaries to page design or the number of images per page, the album can be designed to impart many different aspects of the overall wedding story.

Magazine-style albums are inherently expensive for the client, but every bride seems to want one. Albums

Digital magazine-style wedding albums are elegant and expensive and help the bridal couple achieve a one-of-a-kind wedding album. Note that cover two and page three serve as a title page and scene-setter for the rest of the album. Album and photograph by Jeff Hawkins Photography.

A selection of Digicraft Albums' more interesting albums: magazine style (left), mini-albums (top right), and leather bound (lower right).

Australia (www.albumsaustralia.com.au) even offers special covers that are in keeping with such a luxurious, elegant album. How about something futuristic like a brushed aluminum cover? Or something natural like pearwood with a golden spine of leather imprinted with autumn leaves? Or maybe something really unique, like "fusion"—a brushed metal cover that can be accentuated with a spine that resembles modern art? Maybe the couple would prefer something romantic, like cedar with a leather spine emblazoned with monarch butterflies. For the extroverted bride, maybe something dramatic like Chili Red Leather? And then, of course, what could be more classically modern than the black & white photo cover, spined in black leather? These are just a few of the possible cover combinations that this company offers.

Mini-Albums. Wedding photographer Martin Schembri likes to create what he calls "mini-magazine books." These miniature versions of the main album are small enough for brides to pop in their handbags to show all of their friends. Since they are so portable, the miniature albums get far more exposure than a large, expensive album. This also works as a great promotion for the photographer.

SOFTWARE

Digital output allows the photographer or album designer to create custom backgrounds, inset photos, and output the pages as complete entities. Sizing the photos does not depend on what size mats you have available, you can size the photos infinitely on the computer. Once the album's page files are finalized, any number of pages can be output simply and inexpensively. Albums can also be completely designed on the computer in programs like Photoshop, QuarkXPress, InDesign, or PageMaker—or by using one of the specially designed programs specific to the album manufacturer.

Martin Schembri's Design Templates. Martin Schembri has created a set of commercially available design templates that come on four different CDs and are meant to help photographers create elegant album page layouts in Photoshop. The design templates are drag-and-drop tools that work in Photoshop, and four different palettes are available: traditional, classic, elegant, and contemporary. The tools are cross-platform, meaning that they can be used for Mac or PCs, and are customizable so that you can create any size or type of album with them. More information can be found at www.martinschembri.com.au.

Yervant's Page Gallery Software. Yervant Zanazanian is perhaps Australia's most decorated wedding and portrait photographer. He is also a digital pioneer, having been named AIPP's Digital Artist of the year Award in 1994. Because of his expertise in digital and his creativity as an artist, he was asked to design software that was easy for wedding photographers to use, inexpensive, and would not be used by every lab in the country. He came up with Page Gallery software—a system of automated wedding album templates (www.yervant.com.au).

Page Gallery offers a vast number of layout options for individual design. All you have to do is choose an image file; the software will crop, resize, and position the image into your choice of layout design—all within three minutes. It gives you fully automated options for changing a color image into a black & white one, introducing color tones, and adding special effects for artistic results. The templates vary from very simple and classic designs to more complicated options, allowing the designer to compose a personalized album result with each and every client.

Even though Yervant's studio is perennially busy and his talents are sought after by clients from around the globe, he goes over every single image in every album that leaves his studio. He maintains the strictest level of quality because he is involved in every wedding album the studio creates.

Montage Software. Many wedding photographers use both traditional wedding albums *and* magazine-style bound digital albums. Montage ProVision from Art Leather Albums is a proofless software program that allows you to design either type.

Montage ProVision is a drag-and-drop program that lets you position images with ease and efficiency. The program allows you to use image "proxies," which are low-resolution facsimiles of the images. The program automatically resizes images to the resolution specified by your lab for printing. Further, MontageProVision allows you to refer to contact

Two pages from the same Martin Schembri album let you see similar design elements at work—the creamy tone of the backgrounds and the stark quality of black used sparingly as an accent in both pages. Such graphic themes unify the pages within an album.

ABOVE—The title of this wonderful page or montage is called, *Wooing Fabio*. It was created by Yervant Zanazanian. The image series was carefully conceived and crafted against a brilliant red and yellow wall. It incorporates great design and great joy—the essence of fine wedding photography and great album design. **FACING PAGE, TOP**—Tension and balance are the keys to this album spread's success. The large image of the bride is balanced against the striking image details at left. The "bridge" between the two elements is the use of the script "L." Images and design by Yervant. **FACING PAGE, BOTTOM**—Rhythm and motion are evident in another page design by Yervant. The viewer's eye travels back and forth, directed by the positioning, size, and tonality of the images. It is amazing how simple a great design can be.

sheets when designing the album; review pages and storyboards; and create a wide range of digital effects.

The design process can be done quite easily with the couple sitting alongside the photographer, making suggestions and offering approval. The screen versions of the pages are exact replicas of how the final pages will look.

Once the album has been approved by the couple, the program seamlessly orders all of the album supplies or prepares the files to be uploaded to the lab. Montage ProVision has an extensive network of pro labs, or will work with your lab to produce the pages for the album.

ALBUMS CAN BE LABOR INTENSIVE

With the popularity of magazine-style designs, wedding albums have certainly become more beautiful and expressive. However, they have also become increasingly labor intensive—requiring many more images and much more retouching/enhancement time than traditional albums. Here are some tips for making it work.

Don't Overwork Your Images. Martin Schembri's albums are all digital—from design, to page layout, to output. He feels that when photographers are new to Photoshop, they often spend too much time working on their images. Martin, whose albums include 60 to 100 images, says that between scanning, retouching, page design, print output, and album assembly, completing an album takes between three and four weeks. Therefore, the time spent reworking images in Photoshop is kept to a bare minimum. He averages roughly half an hour per page, including scanning, cleaning up the images, and finishing the layout. Keeping it simple is his bottom line. He only spends two to three full eight-hour days per album.

A Specialized Workflow. Jerry Ghionis owns and operates XSight Photography and Video, a studio with a thriving wedding business. With only a handful of staff, Jerry had to design a specialized workflow that keeps the album production really humming. Jerry's brother Nick (a partner in the business) and wife Georgina (also a partner in business and the office manager) work with five full-time employees, including a digital production specialist, a digital artist, a color analyst, and an album coordinator. The team is capable of producing five albums per week. Says Jerry, "Our whole post-production workflow has been digital for about four years. Whether the wedding has been photographed digitally or shot on film and then scanned, every single image goes through the computer."

There are six stages in producing an album within XSight's workflow. First, they pre-design the "perfect" album with TDA (total design ability) Albums

This is an example of a two-page spread being designed in Albums Australia's TDA software, a drag and drop system using templates. The images available for layout appear along the bottom of the screen.

Australia software, a drag-and-drop template system supplied to customers using Albums Australia albums. After the album and sales order are finalized with the client, the staff prepares all the images, cleaning up and color correcting the photographs. After the files are double checked (tweaking the color, choosing effects, resizing, etc.), the pages are designed, burned to CDs, and sent to the lab. When the images are returned, the album is assembled.

Rather than having everyone produce an album from start to finish, Jerry believes it's important that everyone concentrate on what he or she does best. Five album orders are booked every week, and the workflow remains the same.

Clients are quoted a 10-week production time, although the studio's internal schedule suggests that they are capable of producing an album within 7–8 weeks. Jerry says of the timetable, "We allow a buffer of two weeks in case of any delays or any unforeseen circumstances from our suppliers so that we don't have to upset an eager client. The client doesn't know about the buffer, so if everything is on time, we often pleasantly surprise them with news that the album is ahead of schedule."

Get the Client Involved. Jeff and Kathleen Hawkins care a great deal about the quality of their product. They realize that the wedding album is likely the first album their clients have ever designed—and that the process can be stressful. Therefore, they don't leave it all up to the couple. All of their couples receive an album-design consultation session, during which the team walks them though the design process. It is their goal to have the couple's album designed and put into production within two weeks of their wedding day. After the design session, the couple leaves the studio with a computer printout of what their final album will look like. As Kathleen says, "This is a family heirloom—we can help them make a storybook, not a scrapbook."

THE PHOTOGRAPHER AS GRAPHIC ARTIST

Charles Maring, a New England wedding photographer who has won numerous awards for his wedding albums, sees digital photography producing a brand new kind of wedding photographer. "I consider myself as much as a graphic artist and a designer as I do a photographer," he explains. The majority of Maring's images have what he calls "layers of techniques that add to the overall feeling of the photograph." None of these techniques would be possible, he says, without the creativity that Photoshop and other programs such as Painter give him. "Having a

complete understanding of my capabilities has also raised the value of my work. The new photographer that embraces the tools of design will simply be worth more than just a camera man or woman," he says.

"The design factor has also given our studio a whole different wedding album concept that separates us from other photographers in our area. Our albums are uniquely our own, and each couple has the confidence of knowing that they have received an original work of art. I am confident that this 'Design Factor' will actually separate photographers further in the years to come. I have seen a lot of digital album concepts, some good, some not so good. When you put these tools in the hands of somebody with a flair for fashion, style, and design, you wind up with an incredible album. There is something to be said for good taste, and with all of these creative tools at hand, the final work of art winds up depending on who is behind the mouse, not just who is behind the camera."

Page design is something that more and more photographers are becoming aware of and skilled at. The following are a few basic guidelines for good page design.

Shape. Shape is one of the common artistic elements found in good photography as well as good page design. Shape is nothing more than a basic geometric form found within a composition. Shapes are often made up of implied and/or real lines. For example, a classic way of posing three people is in a triangle or pyramid shape. In any good portrait, the lines and positioning of the body, specifically the elbows and arms, create a triangle base to the composition. Shapes, while more dominant than lines, can be used similarly in unifying and balancing a page layout.

When designing a page, the designer will look at the shapes found in the individual page elements. These may be photographs or other graphic elements.

Becker loads his weddings with details. He never scrimps. If he thinks there's a shot there that will enhance the album, he works it until he gets what he wants. Here, a wedding wreath adorns the gorgeous front door of the bride's home. It's a touch of class that will forever be a fond memory to all who attended the couple's wedding.

In either case, shapes combine to help unify the layout, causing the eye to roam across the pages.

There are an infinite number of possibilities involving shapes, linked shapes, and even implied shapes—but the point of this discussion is to be aware that shapes and lines are prevalent in well-composed images and are vital tools in creating strong visual interest within a layout.

Line. Lines within a design can be real or implied. A real line is one that is obvious—a horizon line, for example. An implied line is one that is not as obvious; the curve of the wrist or the bend of an arm is an implied line. Further, an implied line may jump from shape to shape, spurred by the imagination to take the leap.

Real lines should not usually divide the page into halves. It is better to locate real lines at a point one-third into the page. This creates a pleasing imbal-

ance—the design is "weighted" toward the top or bottom, left or right. This is akin to the compositional rule of thirds.

Lines, real or implied, should lead the eye toward a center of interest on the page. Lines are meant to modify and enhance the main subject element in the design. A good example of this is the country road that is widest in the foreground and narrows to a point on the horizon, where the subject is walking. These lines lead the eye straight to the subject, and in fact resemble a pyramid—one of the most compelling of all visual shapes.

Direction. No major element in a design should ever be dead center on the page, unless symmetry is the object of the design. Most times, just as in good photography, designs are most pleasing when asymmetrical. Just as line and shape help transport the eye through the design on the pages, so each element should provide some form of direction. An image of a person with their shoulders set squarely, looking directly into the camera has almost no direction. Such an element acts like a stop sign, freezing the eye at that point in the design (which is, of course, just fine if that's the object of the design). The point is that there should be a conscious choice made when using these elements in a design.

When picturing people in large images on a page, the rules of direction still apply. Regardless of which direction the subject is facing in the photograph, there should be slightly more room in front of the person (on the side toward which he or she is facing). For instance, if the person is looking to the right as you look at the scene through the viewfinder, then there should be slightly more space to the right side of the subject than to the left of the subject in the frame. This gives a visual sense of direction. Even if the composition is such that you want to position the person very close to the center of the frame, there should still be slightly more space on the side toward which the subject is turned.

The subject of this page is the two little girls, but Scott Eklund has produced a beautiful page with direction by creating a diagonal line (top left to center) and then a second diagonal (lower left to top right). He further unified the page by incorporating the box behind the images, which lets you know the images are tied together and have some logical order in which they should be viewed.

ABOVE—Notice that left- and right-hand pages, when they work well together, force the eye toward the gutter of the album. Album and photograph by Vladimir Bekker. LEFT—In this album spread by Jerry Ghionis you can see a good example of tension and balance. The horse and carriage, by their size, are dominant; however, the limo is equally dominant by virtue of its tone. Both images form a V shape, which leads the eye to the middle of the spread. The black & white photos are independent images to be viewed on their own, but they are secondary to the two large color photos.

Right- and Left-Hand Pages. Look at any well-designed book or magazine and study the images on left- and right-hand pages. They are decidedly different but have one thing in common; they lead the eye into the center of the book, commonly referred to as the "gutter." These pages use the same design elements photographers use in creating effective images—lead-in lines, curves, shapes, and patterns. If a line or pattern forms a C shape, it is an ideal left-hand page, since it draws the eye toward the gutter and across to the right-hand page. If an image is a backward C shape, it is an ideal right-hand page.

Familiar shapes like hooks, loops, triangles, and circles are used in the same manner to guide the eye into the center of the two-page spread and across to the facing page.

There is infinite variety in laying out images, text, and graphic elements to create this left and right orientation. For example, a series of photos can be stacked diagonally, forming a line that leads from the lower left-hand corner of the left page to the gutter. That pattern can be mimicked on the right-hand page, or it can be contrasted for variety. For instance, in the example above, a single full "bleed" (extending

Jerry Ghionis is a talented photographer and album designer. Here he used two blocks of images that counterbalance each other, and lots of white space for a clean look. Each block of images is a storytelling unit.

to the edges of the page) photo with a more or less straight up-and-down design produces a blocking effect, stopping the eye at the vertical within the image. The effect is visual motion—the eye follows the diagonal on the left to the vertical image on the right.

Tension and Balance. Just as real and implied lines and real and implied shapes are vital parts of an effective design, so are the rules that govern them: the concepts of tension and balance.

Tension is a state of imbalance in an image—a big sky and a small subject, for example, creates visual tension. Balance occurs when two items, which may be dissimilar in shape, create a harmony in the photograph because they have more or less equal visual strength.

Although tension does not have to be "resolved" within a design, tension works side by side with the concept of balance so that in any given image or page layout there are elements that produce visual tension

and elements that produce visual balance. This is a vital combination of artistic elements because it creates a sense of heightened visual interest. Think of it as a musical piece with varying degrees of harmony and discord, coming together to create a pleasing experience.

Tension can be referred to as visual contrast. For example, a group of four children on one side of an image and a pony on the other side of the image would seemingly produce visual tension. They contrast each other because they are different sizes and they are not at all similar in shape.

But the photograph may be in a state of perfect visual balance by virtue of what falls between these two groups or for some other reason. For instance, using the same example, these two different groups could be "resolved" visually if the children (the larger element) were wearing bright clothes and the pony was dark colored. The eye would then see the two units as equal—one demanding attention by virtue of

size, the other demanding attention by virtue of brightness.

ADDITIONAL ALBUM DESIGN TIPS

Title Page. An album should always include a title page, giving the details of the wedding day. It will become a family album and it is an easy matter of using a fine quality paper and inkjet printer to create a beautiful title page. Many inkjet printers use archival inks, thus making the digital album heirloom quality. The title page will add a historic element to the album.

Storytelling. Charles Maring, well known for his award-winning wedding albums, believes that each page of the album should make a simple statement or tell a story within the overall wedding story. Instead of cluttering pages, he tires to narrow his focus and utilize images that best represent the moment. He likes to think like a cinematographer, analyzing the images he sees on the computer monitor and reinventing the feelings of the moment.

Maring thinks of the album as a series of chapters in a book. He uses a scene setter to open and close each chapter. Within the chapter he includes a well-rounded grouping of elements—fashion, love, relationship, romance, preparation, behind the scenes, or ambiance. These are the key elements he keeps in mind while documenting the day in photographs.

Color Sampling. One of Charles Maring's tricks of the trade is that he uses Photoshop to sample the colors of the images for his album pages. This is done by using Photoshop's eyedropper tool. (When you click on an area, the eyedropper reveals the component colors in either CMYK or RGB in the color palette.) He then uses those color readings to create graphic elements on the page, producing an integrated, color-coordinated design. If using a page-layout program like QuarkXpress or InDesign, those colors

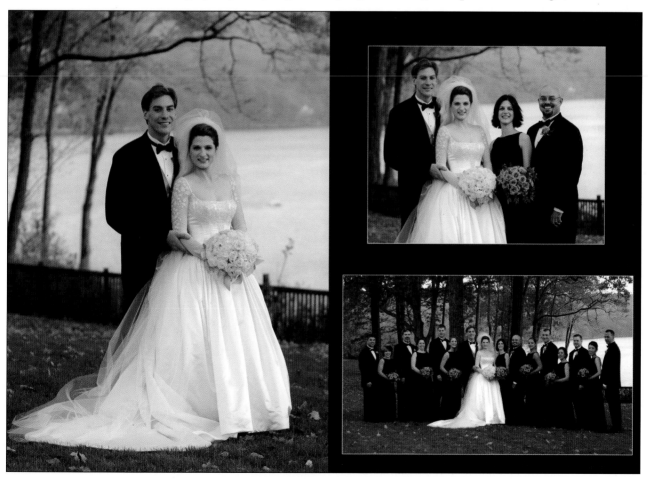

By color sampling the images (using the eyedropper in Photoshop), you can create background tones that coordinate and unify the page. Here, Charles Maring chose the wine color of the bridesmaids' dresses to unify the two-page spread.

can be used at 100 percent or any lesser percentage for color washes on the page or background colors that match the Photoshop colors precisely.

Gatefolds. One of the more interesting aspects of digital albums is the gatefold, which is created using a panoramic size print on the right- or left-hand side, hinged so that it folds flat into the album. Sometimes the gatefold can be double-sided, revealing four page-size panels of images. The bindery can handle such pages quite easily, but it provides a very impressive presentation—particularly if it is positioned in the center of the album.

Albums Australia is one such digital album manufacturer that offers gatefolds as a standard feature of their TDA album design software. This drag-and-drop program offers full preview capability and lets you design the digital album using just about any page configuration you can imagine. The program also features all of the materials variations that the company offers, such as different colors and styles of leather cover binding and interior page treatment.

Double-Trucks and Panoramic Pages. Regardless of which album type you use, the panoramic format can add great visual interest, particularly if using the bleed-mount digital or library-type albums. Panoramics are not an afterthought, since the degree of enlargement can be extreme. Good camera technique is essential. If shooting a group as a panoramic, focus one-third of the way into the group for optimal depth of field and use a tripod to ensure that image is razor-sharp. Make sure that you have enough depth of field to cover front to back in the group. If the bride and groom are the center of your panoramic shot, be sure to offset them so that they don't fall in the gutter of a panoramic or two-page spread.

Award-winning portrait and wedding photographer Ira Ellis calls himself the "King of Panos" (short for "panoramics"). He includes 12 x 24-inch panoramic pages—usually five or six—in every album the studio produces. He says panoramics are guaranteed to produce at least one, "Oh, wow!"

Ira says, "Regardless of the format that you use to capture images, it is important to remember that a 12 x 24-inch panorama has a 1:2 ratio. As long as you maintain that aspect when you compose your image,

you will not have any problem in having a panoramic printed. The secret here, is to just back away from your subject enough, so that what you end up with fits into the 1:2 ratio. Keep your subject to one side of your composition, remembering that the finished panorama print is cut in the exact middle where the two pages hinge."

Ira not only shows prospective clients albums with panoramics, but when he proofs the wedding images, he trims the panoramic proofs to the 1:2 aspect ratio to remind clients that he envisioned the image as a two-page panoramic. Be sure to work out the details of the panoramic printing and binding with your lab or album company so that there are no surprises later.

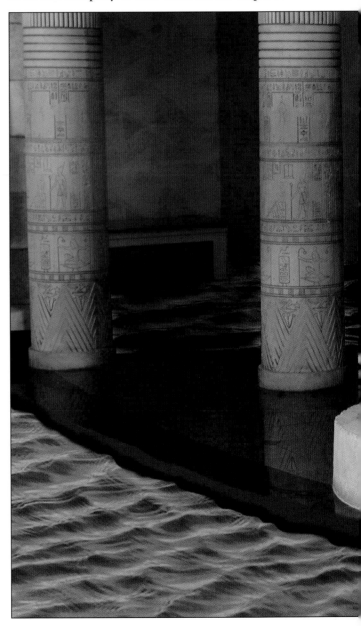

Ira Ellis is known as the king of panoramic images. He promotes them with his clients, so virtually every album he sells has at least one—and usually several. The aspect ratio on these panoramics is 1:2 (12 x 24 inches).

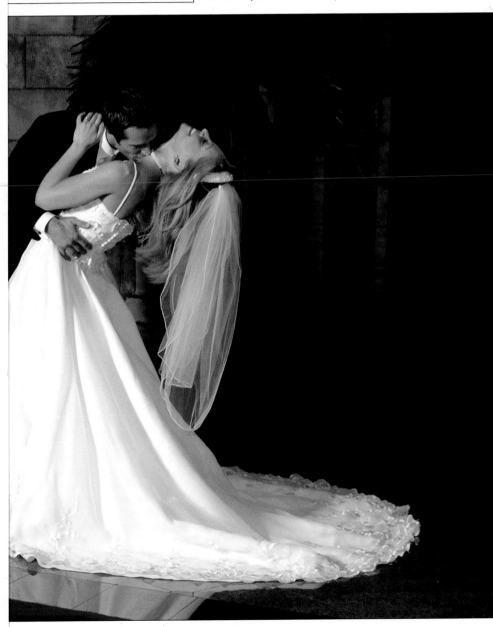

Dennis Orchard
IMAGE GALLERY

Dennis Orchard has been named the U.K.'s Wedding Photographer of the Year and has received similar honors here in the U.S. from WPPI. Humor, experience, and creativity are the keys to his unique wedding style. Underlying these is an artist's sensitivity to a beauty often missed by the less observant eye.

When you log on to his website (www.dennisorchard.com), you are greeted with the message, "Wedding photography without fuss, but with humor and experience."

Dennis worked with *The Daily Telegraph* for many years and draws on his journalistic know-how to capture a unique and modern style of wedding photography, known as lifestyle weddings, which combine both informal reportage in black & white with creative, natural, color photography.

Wedding photography, like all visual media, has been transformed in recent times. Couples no longer wish to pose formally for traditional stereotyped shots, preferring a more fluid and natural approach to their pictures. They ask for black & white or sepia pictures and they hate the thought of spending hours arranging formal groups. Above all they do not wish to have their wedding spoiled by a photographer who dominates the day.

Dennis has listened to his clients' requests and evolved. Family groups, a staple in British wedding photography, are still taken—but with a more relaxed feel. The bride and groom's pictures are taken (usually at the reception) using natural light and capturing natural expressions. Above all, Dennis strives to reflect the fun and happiness of the day.

Dennis shoots with Canon DSLRs and Canon lenses and almost never uses straight flash—although bounce flash is a mainstay of his lighting regime. Where he can shoot by available light, he will. Since group poses are so important to wedding photography in his native England, he poses his groups quickly and encourages his subject to have fun with it, so that creating the images the couple and families want becomes less of a burden and more of a pleasure.

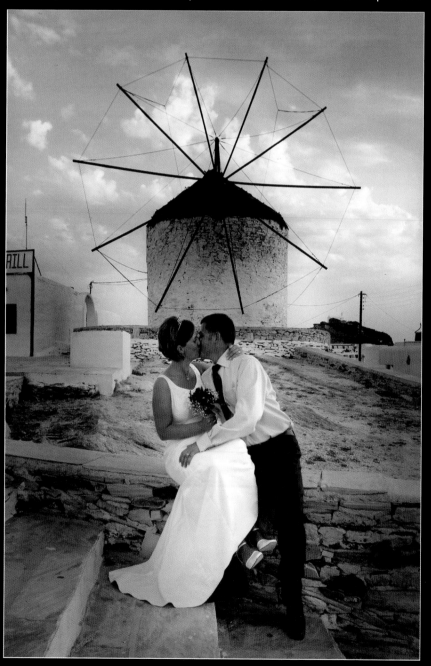

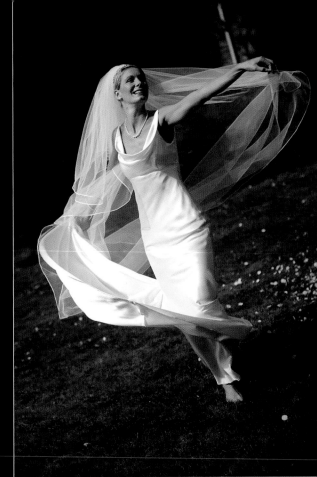
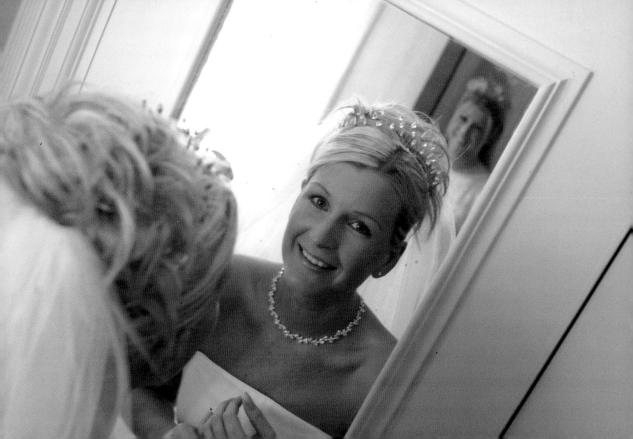

GLOSSARY

Action. In Adobe Photoshop, a series of commands that you play back on a single file or a batch of files.

Bit. Binary digit. Smallest unit of information handled by a computer. One bit conveys little a human would consider meaningful. However, a group of eight bits makes up a byte, representing more substantive information.

Bit Depth. Number of bits (smallest units of information handled by a computer) per pixel allocated for storing color information in an image file.

Bleed. A page in a book or album in which the photograph extends to the edges of the page.

Burning-in. Darkroom technique in which specific areas of the image are given additional exposure to darken them. In Photoshop, the burn tool accomplishes the same job, darkening the areas of the image over which it is passed.

Byte. Eight bits. Used to measure computer memory and storage—i.e., in kilobytes (KB=1000 bytes), megabytes (MB=1 million bytes), or gigabytes (GB=1 billion bytes).

Calibration. The process of altering the behavior of a device so that it will function within a known range of performance or output.

CCD (Charge-Coupled Device). A type of image sensor that separates the spectrum of color into red, green, and blue for digital processing by the camera. A CCD captures only black & white images. The image is passed through red, green, and blue filters in order to capture color.

CF Card Reader. A device used to connect a CF Card or microdrive to a computer. CF card readers are used to download image files from a capture and/or storage device to your computer workstation.

Channel. In Photoshop, channels are grayscale representations of the data used to create colors and tones in an image. These are accessed via the channels palette. The image's color mode determines the number of color channels. An RGB image has four default channels: red, green, and blue, plus a composite channel used for editing the image. Additional channels can be created in an image file for such things as masks or selections.

CMOS (Complementary Metal Oxide Semiconductor). A type of semiconductor that has been, until the Canon EOS D30, widely unavailable for digital cameras. CMOS chips consume less energy than other chips that utilize only one type of transistor.

Color Management. A system of software-based checks and balances that ensures consistent color through a variety of capture, display, editing, and output device profiles.

Color Space. Range of colors that a device can produce.

Curves. In Photoshop, a tool that allows you to correct the tonal range and color balance of an image.

Dodging. Darkroom technique in which specific areas of the print are given less exposure by blocking the light. In Photoshop, the dodge tool accomplishes the same job, lightening the areas of the image over which it is passed.

Double Truck. A layout with an image, usually a panoramic or long horizontal image, split across two facing pages. Usually the image "bleeds" across the two pages.

Embedding. The process of including a color profile as part of the data within an image file. Color space, for example, is an embedded profile.

EPS (Encapsulated PostScript). File format capable of containing both high-quality vector and bitmap graphics, including flexible font capabilities. Supported by most graphic, illustration, and page-layout software.

EXIF (Exchangeable Image Format). Digital imaging standard for storing metadata, such as camera settings and other text, within image files. EXIF data is found under File Information in Photoshop.

Feathering. In Photoshop, softening the edge of a selection so that changes made to the selected area blend seamlessly with the areas around it.

FireWire. A high-speed interface designed to transfer data at speeds of 800MB and higher.

FTP (File Transfer Protocol). A means of opening a portal on a website for direct transfer of large files or folders to or from a website.

Gamut. Fixed range of color values reproducible on a display (e.g., monitor) or output (e.g., printer) device. Gamut is determined by color gamut (the actual range of colors) and the dynamic range (the brightness values).

Gatefold. A double-sided foldout page in an album that is hinged or folded so that it can be opened up, revealing a single- or double-page panoramic format.

Gaussian Blur. Photoshop filter that diffuses an image.

Grayscale. A color model consisting of up to 254 shades of gray plus absolute black and absolute white. Every pixel of a grayscale image displays as a brightness value ranging from 0 (black) to 255 (white). The exact range of grays represented in a grayscale image can vary.

Gutter. The inside center of a book or album.

Histogram. A graph associated with a single image file that indicates the number of pixels that exist for each brightness level. The range of the histogram represents 0–255

from left to right, with 0 indicating absolute black and 255 indicating absolute white.

ICC Profile. Device-specific information that describes how the device behaves toward color density and color gamut. Since all devices communicate differently, as far as color is concerned, profiles enable the color management system to convert device-dependent colors into or out of each specific color space based on the profile for each component in the workflow. ICC profiles can utilize a device-independent color space to act as a translator between two or more different devices.

JPEG (Joint Photographic Experts Group). An image file format with various compression levels. The higher the compression rate, the lower the image quality, when the file is expanded (restored). Although there is a form of JPEG that employs lossless compression, the most commonly used forms of JPEG employ lossy compression algorithms, which discard varying amounts of the original image data in order to reduce file storage size.

Lens Circle. The circle of coverage; the area of focused light rays falling on the film plane or digital imaging chip.

Levels. In Photoshop, a tool that allows you to correct the tonal range and color balance of an image.

Mask. In Photoshop, a selection tool that allows you to isolate areas of an image as you apply color changes, filters, or other effects to the overall image. When you select part of an image, the area that is not selected is "masked" or protected from editing.

Microdrive. A storage medium for portable electronic devices using the CF Type II industry standard. Current microdrive capacities range from 340MB–1GB of storage. The benefit of a microdrive is high storage capacity at low cost. The downside is the susceptibility to shock—bumping or dropping a microdrive has been known to cause data loss.

PC Card Adapter. A device used to connect your CF card or microdrive to your computer. Used to download image files from a capture and/or storage device to your computer workstation.

Pixel. Smallest element used to form an image on a screen or paper. Short for "picture element."

Print Driver. Software that interprets data from a device, usually a computer, into instructions that a specific printer uses to create a graphical representation of that data on paper or other media.

Profiling. The method by which color reproduction characteristics of a device are measured and recorded in a standardized fashion. Profiles are used to ensure color consistency throughout the workflow process.

PSD (Photoshop Document). PSD is the default file format and the only format that supports all Photoshop features. Using the PSD format allows you to save all image layers created within the file.

RAW File. A file format that records picture data from the sensor without applying any in-camera corrections. In order to use images recorded in the RAW format, files must first be processed by compatible software. RAW processing includes the option to adjust exposure, white balance, and the color of the image, all while leaving the original RAW picture data unchanged.

RGB (Red, Green, and Blue). The set of primary colors used by computers and other digital devices to create all other colors. A 24-bit digital camera, for example, will have 8 bits per channel in red, green, and blue, resulting in 256 shades of color per channel.

Sharpening. In Photoshop, filters that increase the apparent sharpness of an image by increasing the contrast of adjacent pixels within an image.

Soft Proof. In a traditional publishing workflow, a hard proof of your document is made to preview how the document colors will look when reproduced on a specific output system, such as an offset printing press. In a color-managed workflow using Photoshop, you can use the precision of color profiles to soft-proof your document directly on the monitor, displaying an on-screen preview of the document colors as reproduced on a specified device.

sRGB. Color matching standard jointly developed by Microsoft and Hewlett-Packard. Cameras, monitors, applications, and printers that comply with this standard are able to reproduce colors the same way. Also known as a color space designated for digital cameras.

TIFF (Tagged Image File Format). A file format commonly used for image files. TIFF files offer the option to employ lossless LZW compression, meaning that no matter how many times they are opened and closed, the data remains the same (unlike JPEG files, which are designated as lossy files, meaning that data is lost each time the files are opened and closed).

Unsharp Mask. Sharpening tool in Photoshop that is usually the last step in preparing an image for printing.

USB/USB 2.0 (Universal Serial Bus). External bus standard that supports data transfer rates of 12MB per second. Particularly well suited for high-speed downloading of images from your digital camera straight to your computer. USB 2.0 transfers data at a much greater rate than USB—at 480MB per second in a dedicated USB 2.0 port.

Vignette. A semicircular, soft-edged border around the main subject. Vignettes can be either light or dark in tone and can be included at the time of shooting, or created later in printing.

White Balance. The camera's ability to correct color and tint when shooting under different lighting conditions including daylight, indoor, and fluorescent lighting.

Working Color Space. Predefined color management settings specifying the color profiles to be associated with the RGB, CMYK, and grayscale color modes. Central to the color management workflow, these profiles are known as working spaces. The working spaces specified by predefined settings represent the color profiles that will produce the best color fidelity for several common output conditions.

INDEX